FADING LIGHT

portraits of centenarians

Chris Steele-Perkins

Published by McNidder & Grace
4 Chapel Lane, Alnwick NE66 1XT

First published 2012
© Chris Steele-Perkins

A catalogue record for this work is available from the British Library.

ISBN: 978-0-85716-032-4

Designed by Chris Steele-Perkins and Obsidian Design

Printed in China on behalf of Latitude Press Ltd.

Acknowledgements

My thanks to all the centenarians and their family members who have taken part in this book, and to the various care-homes that have opened their doors to me, in particular Barchester.

Numerous people have helped with suggestions as the book developed, particularly Mark Edwards.

This project was supported by the 'A Better Life' Programme of the Joseph Rowntree Foundation. With special thanks to Ilona Haselwood.

Contents

Introduction

Homo Longevitus

It was a statistic that got me started. I read that in the UK there were more than 10,000 people over the age of 100. I had thought, probably like many others, that there would be a few hundred, so I was surprised at 10,000 and the figure is growing at an increasing rate, such that the Office for National Statistics predicts that 5% of the people alive today in the UK will live to be over 100. That means 3 million people. Three million centenarians and millions of other very elderly people! A new population group is coming into existence; a new demographic that has never existed on the face of the planet: Homo longevitus.

Only 100 years ago the life expectancy of men in the UK was 50 and of women 54. Now it is 78 for men and 82 for women, and the trend does not seem to be flattening out. This should make us think about the consequences of this development, as the implications are profound. The centenarians are the tip of the iceberg for an increasingly ageing population, one that will simultaneously reduce the productive, income generating work-force and also increase the financial costs, and cultural efforts, of providing adequate care and support for the elderly. This rapidly ageing population demands a reorganising of society and a redefining of our attitudes to age, work and the minimum quality of life that is acceptable. It means redefining our attitudes to illness, mental decline, assisted suicide, withdrawal of medical support and the values we place on life.

Yet statistics are abstract, and this book is about people. It is a portrait of this new generation as it ushers itself into being. They are forerunners of a new human future, and I wanted to make a record of some of them, early in the 21st century, in words as well as pictures. They are, as expected, a mixed bunch, and I believe a reasonable sampling of this demographic, though the more profoundly disabled amongst them are not represented as I could not get access to them.

I leave it to others to fully account for this change in human ageing. It requires an affluent society with high quality health care, and at the anecdotal level, it does seem from the people I met that you tend to live longer if you continue to believe living is worthwhile. It also helps if it is in your genes and your family have been long-lived in the past, though these factors are no guarantee. Whatever the reasons for such long lives, these centenarians did not get killed in war, die in childbirth, get run over by a car, fall off a cliff, drown, or succumb to cancer, heart failure, stroke, asphyxiation, flu, various viruses and poxes. They survived for over 100 years, and I find that somewhat miraculous.

Chris Steele-Perkins / Magnum Photos

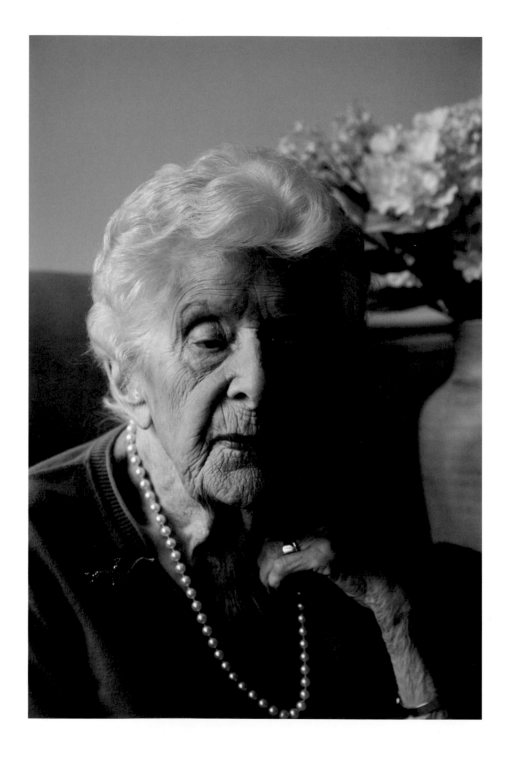

Alice Leake

Born 26 February 1908

I was the member of quite a large family, my mother, my father and five children, and we lived in the country in Linconshire for quite a long time. My father was the vicar of a big countryside place... I was the second girl, there were three girls. I am the last one, the last one in the family. I've got rather a bad back. I've always had rather a slightly bad back, so I had to be careful with it, but nothing serious.

How do you feel now?

Very old sometimes, (laughs) other times I feel I could do anything you know, when my back's all right. Quite good really... I had a tragedy with one child... Lovely baby to look at, but almost as soon as she was born, when the doctor came to see her and he clapped his hands she never turned round or showed any sign that she heard it, so he said "I think that child's deaf." Then we discovered she couldn't do anything. She didn't seem to be able to take an interest in anything, didn't speak, didn't move, didn't do anything. Jilly never spoke, ever, but she looked normal, completely normal, so she never came out of there (a home) and she died there... So that was our tragedy... Certain things I can't do. I can't do buttons up. My fingers are completely dead. I used to do a tremendous lot of needlework. I taught needlework for dress making and now I can't even hold a needle! I'm very sad really because when I was away four of the people who live here, almost as soon as I got back... I must have been here before... Anyway I knew them before, these four. They died. She (Mary) was a great friend of mine. And another one was a great friend. Then she suddenly got cancer. This was all within the first six months of when I came back here, so I felt very sad. It's very difficult to make friends again after you've had such deep friendships. I felt very lonely and sad sometimes.

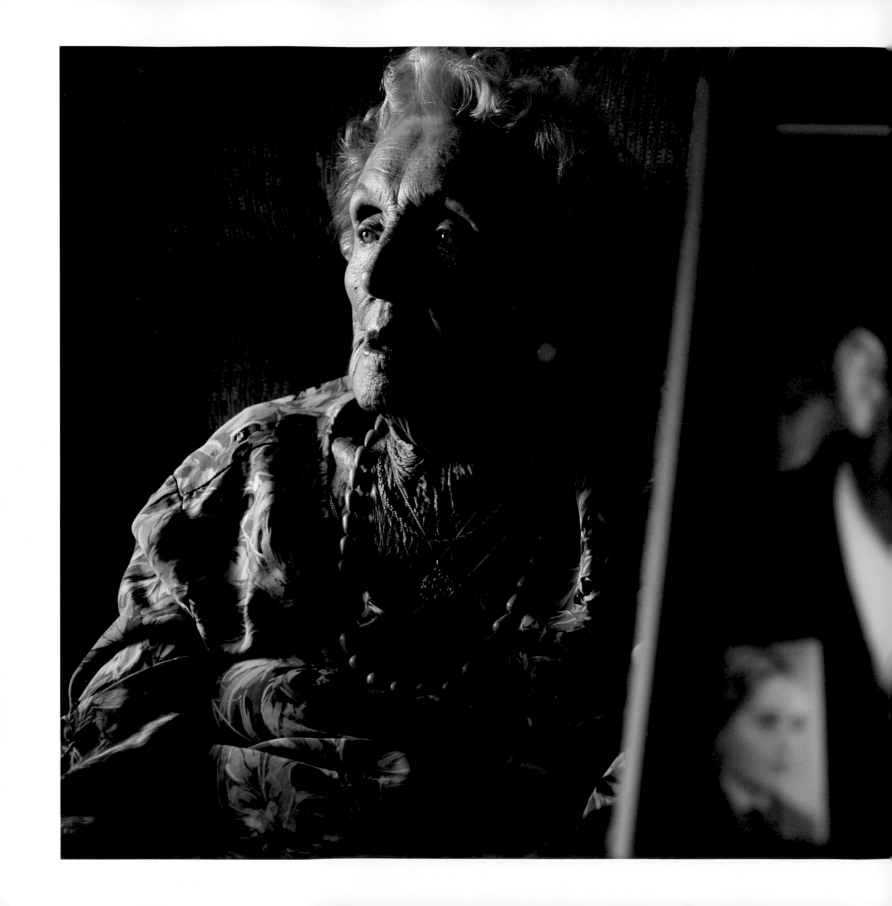

Marjorie Cowel

Born 23 March 1909

What do you think has made it possible for you to have lived so long?

Because I love life! I love life and I am terribly interested in everything and I always feel happy. People look back and say "You've had a very eventful life, don't you feel sad?" And I think, no, this is my home here, my room, my home. I'm lucky enough to have enough money to be here because it's expensive. I've got a lovely view, a lovely garden, nice carers and I have lots of friends who come, you see, and we go out and we go all over the place, we go to the seaside. We go everywhere. And I can walk with my walker and I can get into a car. I mean people are awfully kind, and I can still play bridge. We are going to play bridge on Thursday or something.

People forget, but it happens I have a very good memory and can remember back to my earliest childhood. I've always had a very happy life. And if you like life people seem to like you... Well, I don't feel any different really to when I was a young woman. I am lucky aren't I, that I am as well as I am? Well, I find the world a very pleasant place to be... When I wake up the sky is beautiful, it was lovely this morning, all pink, and it just makes me happy seeing birds.

Helen Turner

Born 27 February 1910

You still obviously enjoy life.

Yes, oh yes, I'm going to live to 110! I don't know why I have chosen that figure but, well, I might go beyond that. I might go to 120 (laughs).

Did you have a party?

Oh did I? Yes! I'd invited so many friends and I was going to get champagne as it's 100. So eventually there was, in this small flat, forty-one people! They were here, they were there in the hall. In the kitchen. But they all enjoyed themselves, they were all happy, not just standing and in cliques together, they were just friends that I'd met, and of course I had a letter from the Queen, well, nice card from the Queen, not just for me of course but it was nice to get it. And actually you know I can't really remember much of it, the party, because I'd had a lot to drink that night (laughs).

Did you ever get married?

I was engaged once but I never met anyone who would, well, I knew what I was looking for and I actually found it but too late, and it's somebody that I've met on the common, and he's a professor and he teaches economics, I think it is. Of course he's married. And I can't imagine he's the sort of person that could go off the rails at all. Not that I wouldn't want him to. I'm not saying that I'm that good! (laughs) But he is very fond of me and he said, "I'm very fond of you Helen" but I told him, "I'm very fond of you, but it's too late." But now, he's a person I'd like to have married. And I've never met anybody else.

Every morning I go for a walk. Unless it's teeming down, then I think I'm going to get drenched so I have to wait and if it leaves off I might go in the afternoon. If it's raining just a bit I don't mind because I've got rain-wear and that. And then I come back and get my breakfast because I haven't had anything before I go out. Then I do what I have to do in the house. Sometimes I think "Ooh no, I'll not do it today." Then I do shopping and then I sit down and maybe I'll do about two hours German, and then perhaps I'll get myself something to eat, and if I feel a bit tired perhaps go and have a rest, and in the evening I come again and sometimes, [indicates book] this is a Bible, I read the Psalms in that. I like the Psalms and I know lots of them by heart especially the 91st Psalm. I usually say that to myself before going out. And this is true, I'm not just saying that. In the 91st Psalm "He that dwelleth in the secret place of the Most High shall abide in the shadow of the Almighty." The secret places are within you, well, within everybody because God's in everybody. "And he will give his angels charge over you."

Well, I was coming back one morning and it must have been about March, when the mornings were really dark, and I was aware somehow of two men opposite on the other side of the road. And there was a black man and a white man and the black man said, "My friend says I mustn't put my dirty black hands on you" and I said, "Well he's speaking the truth isn't he? Because that's what you mustn't do isn't it?" And he looked at me and he said, "Aren't you afraid of us?" I said, "Why should I be afraid of you? What have I got to be afraid of from you?" And he said, "Oh no, stop you're too holy, I can see that, nobody is ever going to touch you." "Well" I said, "I'm glad you think that way, now if you don't mind I want to get back because I want to get my breakfast." And then both of them said, "Yes" and they were very quiet and then walked away. And I knew then that prayer, that he would give his angels charge over me. It might sound stupid, but I believe it. And it happened to me.

(Later, waking in Wadsworth Park at 7.00 a.m.) Isn't this just beautiful? This is the most beautiful time of day. Look at the colours. Beautiful! I sometimes think Heaven must be as beautiful as this.

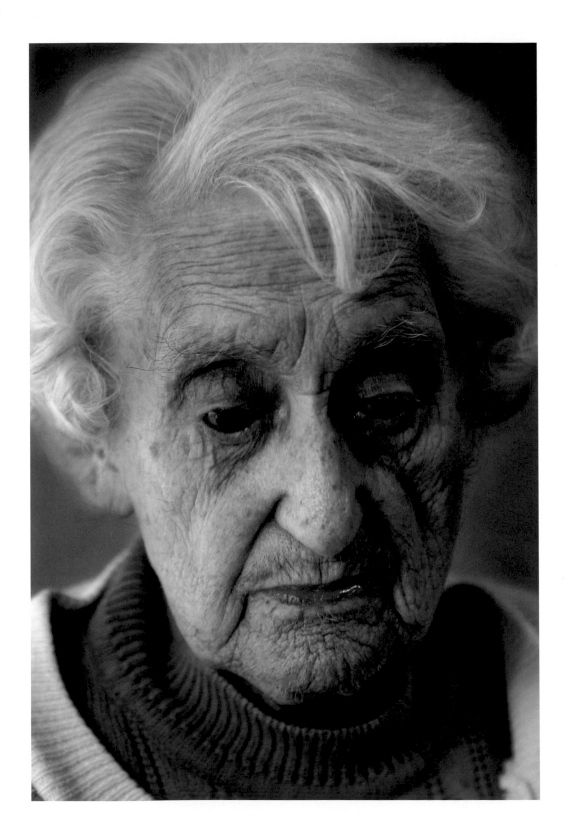

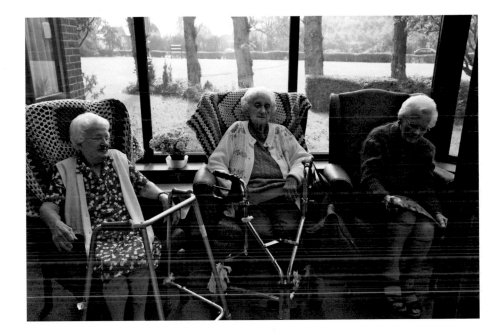

Nellie Wright

Born 15 August 1907

I don't get by, I exist from one day to the other. I'm hoping for the end to come any time. I'm tired of it. Why should it be like this? Not a penny in my purse! I've worked 74 years. My second husband was a good man. He left me the house. I can't get it! No. I'm one of the Done Downs. I've been done down. All because of trusting people. I believe in God. I know soon he can settle this for me! I'm here! Why am I here? I didn't apply to come here. No. No! I was shepherded here. I won't say any more. Where is my money? I worked all these years, I should get a pension from the government, an old-age pension, a widow's pension, the crippled pension because of this accident. I never see them, and I should have another pension from the other marriage.

How long have you been living here now?

Four years. Four years too much. Yes. I'm waiting to God to straighten this out and he will. I have no right to be here! I should be home! I had a nice little garden. My husband built me a little garden in it. He died while I was in here. I never even got to his funeral. It doesn't matter. I can still exist. That's all I do, existing. I've still got my spirit. Yeah. My British spirit!

What do you think kept you going for so long?

The knowledge that I had very good parents and brothers and sisters, and I've been a decent girl, and never go wrong, and have never drunk and gone with men! Or anything. I've just lived and worked like a silly fool.

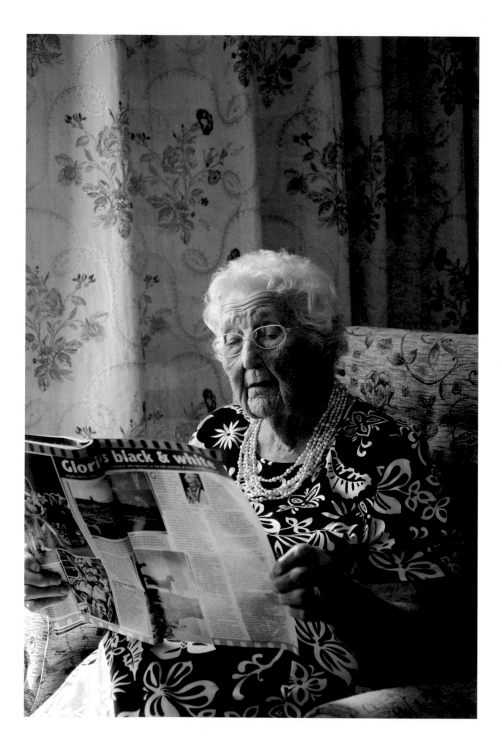

Nora Hardwick

Born 28 November 1905

What do you put it down to that you've lived so long?

Well, it's in the genes, I suppose, my mother was 94 and my eldest sister, she was 96, my old granny was 97, and the other sister she was 91. My brothers; two of them lived in the 90s. The others were in their 80s. There were eight of us... But now old people have got a better quality of life. Better living conditions, and there's financial help if they need it. And I have a little shot of whisky at bedtime. That helps I think (laughs). I've kept my brain active. I've kept myself active and I read and do crosswords.

I'd have to have somebody [help me] if it wasn't my daughters, I'd have to have somebody every day, but you see Maureen has showered me today and Jan's done washed my hair. Looked after me. Well, they keep me clean, that's the main thing. All I have to do is wash my pots up, make the bed. I managed to do that, and put the rubbish in the bin, and managed to do that, but it's a struggle getting in and out because of that steep step.

I've treated myself to a little buggy, scooter thing, that I can get out on the pavements. Get out in the fresh air. I like to get out and about, I don't like sitting all day. It's when you lose your independence that it sort of, upsets you.

And in terms of your car, do you have to take a test every year?

No. No, I can truthfully say I can just fill out the form, eyesight is good. My hearing. I can hear you, but sometimes I can't always understand what you say, so I've got a hearing aid that I put in.

Do you think we could go for a drive then?

Well give me my coat then. It's getting from the door to the car, that's the worst bit. I'm all right once I'm in the car.

(Later, after a drive round country lanes)

You took your life in my hands. (Laughs)

I felt fine. I'm very impressed actually.

I don't want to drive to London! But it's there if I want it. That's what I do to get the battery charged.

Have you set yourself a target, for example, "I'm going to live to 110?"

Oh no, I take each day as it comes. Every day is a bonus. Every day is a bonus.

How do you feel?

I feel fine. I like being in company. That's the worst part see, in the evenings, when you're on your own. Mind you I've got television, but sometimes it's such a load of rubbish on that doesn't interest me. Then I pick up a crossword.

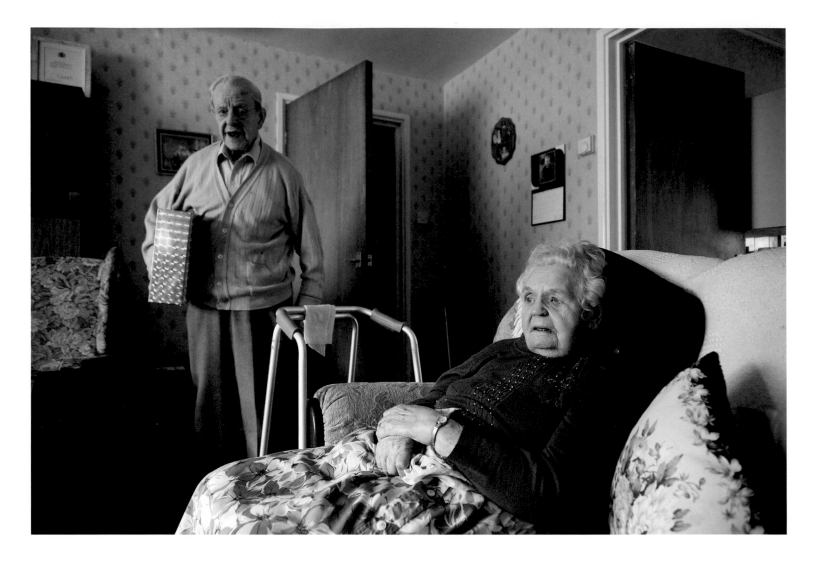

Ralph (R): (showing a photo album) I can't see very well and I can't hear very well. I have to admit I'm getting old. This is the coat of arms of my family. Believe it or not Tarrant's were put in the Domesday book in 1085... This is your life... Born on 7 July 1903... That's the church we were married... That's my mother... That's my father... That's where I were born... There we are when I were first born... That's my brother Eric... That's my sister... This is a school where I were educated.

Phyllis (P): I went to Western Road School.

R: That's when I first started football, that's me there...13 years of age then.

P: I left school at 14.

R: Those are my office days... The office in the steelworks... That's Phyllis again look... Now we're getting to some good ones here... That's me... That's when we were at Llandudno on honeymoon... That's with her mother and father ...1931 holiday.

P: (to me) Are you kneeling down? You ought to have a cushion.

Ralph and Phyllis Tarrant

Born 7 July 1903 and 9 September 1908

R: This is our wedding… That's when we lived on Salisbury Road… Another holiday photo…

P: Salisbury Road was a lovely road when we lived there.

R: This is the Olympics in Germany when old Hitler grumbled about him (Jesse Owen) winning… Kids growing up… That were in our back garden… Wasn't there a lovely dog that?… Neighbours… This is where I got called up… Aylesbury, where ducks come from…. That's the RAF badge of course… That's the time when Chamberlain got the "No more war"… I was stationed on flying boats… About '43… This is when the kids were growing up… I didn't see much of them. I missed all that… These are different paintings I copied… I've still got oil paints and brushes.

P: I'm beautiful you know. I don't think!

R: That's in the garden there with neighbours… That's another group that was down here… That's in the paper. Telegraph and Star I think… That's from the Queen…

P: That's one thing, I've still got my senses, where some poor souls, as they get old, they don't. Shall I do some acrobatics now? (Laughs).

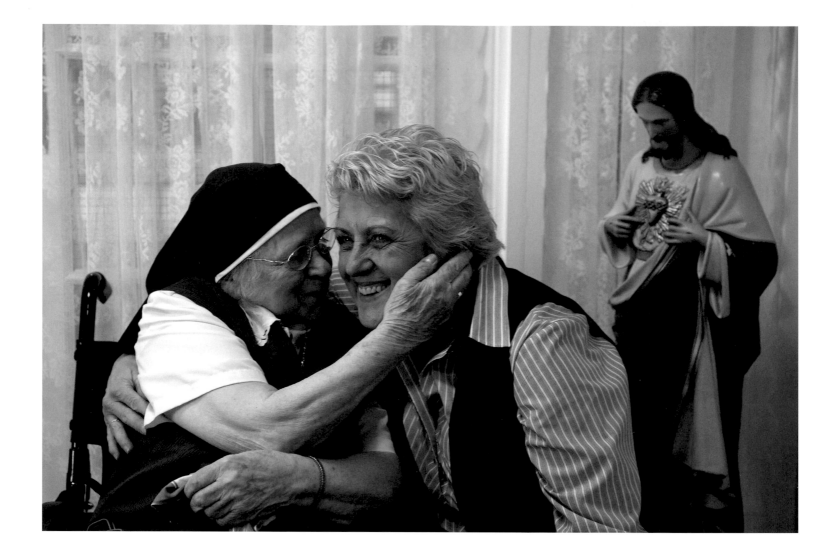

Margaret Grimsdale

Born 4 July 1910

I've had a wonderful life! I've had a hard life, but there it is (laughs).
You've got to have a sense of humour. Yes, that's me. Really I'm
a terrible person. I'm a naughty nun. Always in trouble, doing
something wrong. Oh yes! I had a card from the Queen. And I've
taken a nice photograph of the Queen myself, and I'll let you have
it. And she's sitting so straight, so very erect. I love the Queen!
She's never put a foot wrong. She's a wonderful lady! A wonderful
lady. I'll let you have it. As a matter of fact, I'll go and get it now
before you go. I keep falling over you see. I've been on the bottle
(laughs). Do you do many jokes? Oh, I tell lots of jokes. If you saw
two peas on the table, two peas, what would they be? Bachelors! Oh,
you don't know nothing yet! Oh. If ever you get the chance to go to
Lourdes. Go! Wonderful. Wonderful! Twice I have been. Three times.
It's a wonderful place to go. And you don't need to be a Catholic to
go to Lourdes. It's really wonderful and there's no grumbling, no
complaining. "I've got this, I've got that." And the place is beautiful.
Really wonderful! So I think I'll be dead in a few weeks because I've
reached over 100 now, but I am finding life very hard. Very difficult,
and I'm very low in spirits. I can't say I'm really, really happy here,
and now that I'm getting much older and stupid! I don't want to go
around. I don't socialise like I used to. I keep to me self, which is
wrong, but I can't help it.

Don't you think it would be nice to get to 101?

Oh no! No. There's only one place I want to go and that's to die.
I want to die now. I want to die and be with the Lord. Yes. That's all I
want now. Because what else is there to live for?

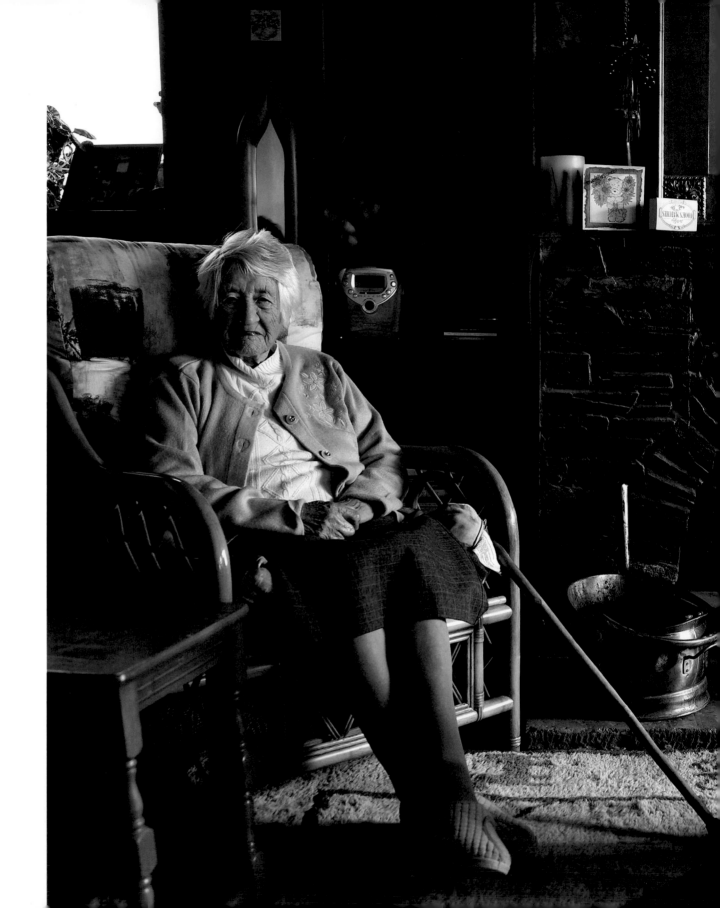

Rosa Elen Billing

Born 16 June 1909

How do you feel?

Oh, very well thank-you (laughs).

Can you tell me a bit about your life?

Well, I was born, it was on the moors. I went to school from there, about two miles. Walked every day. I left school at 14. Worked on the farm.

How did you meet your husband?

Well, going to chapel I expect. Yes, must have done (laughs).

Do you remember the first time you met him?

No!

How old were you when you got married?

25. Yes, 25.

Are you a Methodist?

Yes. All me life. Till the chapel closed. I was organist for, what... 25 years?

Daughter (D): No, no, mother! You started when you were 14 and you didn't retire till you were in your 90's. You have a certificate for 75 years don't you?

Yes, must have been (laughs).

Do you still play?

Yeah. Got an organ there I play. Behind the door it is. I still play it. I'll take me coat off before you take any more (photos). It looks better with it off.

D: No it doesn't! It's not a coat, it's a cardigan dear.

What do you think it is that gives you such a long life?

(Laughs) I don't know. Good health is one thing, isn't it?

D: She's always worked really, really hard, because she's been widowed for over 50 years, 'cause you didn't get any money in those days. Anything to make a bob or two.

Can you walk around still?

Oh yes, with my stick. Quite all right.

Have you got any hobbies?

Oh, yes, playing scrabble (laughs). I used to read quite a bit. Ethel M. Dell, she was a great favourite.

Are you glad you made it to one hundred, Does it seem worth it?

Yes, oh yes. Specially if you've got good health. That's the main thing isn't it? I sleep all right and eat all right.

What has made the biggest difference to you in your lifetime?

Well, when me husband was killed, I suppose.

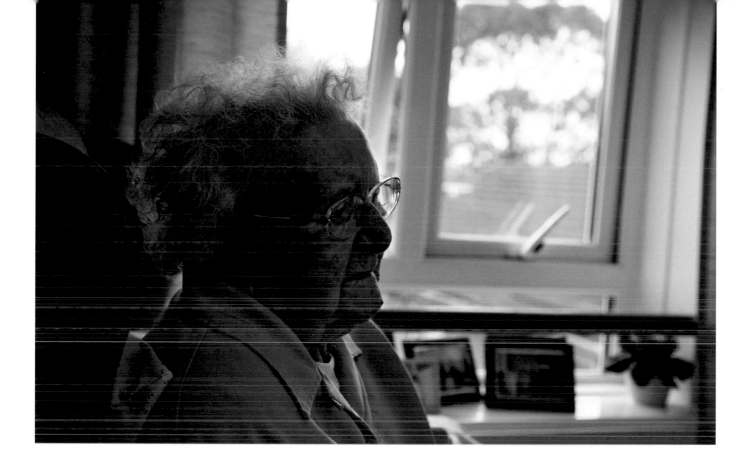

Emily Irene Tyrell

Born 23 October 1910

How did you meet your husband?

Well he just came to live in the village, and we met and fell in love. That was it. We had a very happy marriage but unfortunately we had no children. It was just one of those things. We did nothing to prevent them. We were married in 1936 and, unfortunately we had no children. They just didn't come along, so that was that sort of. You can't make things happen like that... My mother lived with me for 24 years. I think she was 96 when she died. I looked after her and she was quite happy when she lived with us. I can truthfully say we never had a cross word, and she was very fond of my husband, and he was fond of her. So we plodded on.

Did you have brothers and sisters?

No (coughs) no, I was an only child unfortunately. So, just one of those things I suppose. I had no children of my own unfortunately. That wasn't to be I suppose... I lead a fairly – what shall I say? A comfortable life. I'm quite happy to be here and be looked after. I think it's a great thing to say that you are well looked after. Sometimes I wonder how much longer I can go on as I am, but still, there you are. What is to be will be... Well, it might sound silly to some people but I am not unhappy here at all. I've got a good outlook here and there is a big tree, and maybe this sounds silly to you, but there's a tree, a big tree, over there and I watch the wind blowing some days, and I see what happens. Very often I sit here and watch the wind, and watch the weather.

Simon Martinez

Born 18 February 1910

I was born in Belize, it was British Honduras then, now Belize, in Central America. In the last World War our government recruited about 500 men for work in the forestry in Scotland. So, I was one of them forestry workers. We were divided all over Scotland.

Did you like it?

Well, that was all our job. We were forestry workers, wood cutters back home, so it wasn't difficult.

What about the temperature?

Well, the temperature, we live through it! It was two different temperatures, from the tropic to the freeze-zone, but at least it didn't affect me. I was lucky because the day we land here we were right off working in the snow. We arrived here on November 26 1942 and were all separated into our different groups and next day we were knee deep in the snow, working. Thank God we never looked back... After the war finished the camp was dismantled, broken up, and Harold Macmillan was looking after the colonial people that had come round, and he came along and he tell us, "The men that want repatriate, just apply and those that want to stay, you are all Britishers in this country you can stay as long as you want." So therefore I was one of the group that stayed and live in Edinburgh. I'm a Britisher, right! I've been in the country from 1942 and I just keep going. After the camp we came to Edinburgh and we live quite happily, getting integrated with the people. I've always been in Edinburgh ever since. I made one trip back home and that was about 30 years ago.

You don't miss it?

Oh no... I don't miss anything, me. You only live once. That's how I look at life. I personally. I don't miss anything. When I leave my family back home I never sit back and talk about I am homesick, I miss this that or the other. I never do because life is wonderful, life is great if you are healthy, you can go around. Yes, I keep in touch with my family, and that picture there on the TV is sort of my family back home. My family here keep in touch with them.

Are you living by yourself?

Yes, but my children come to see me, and I got a social worker that join me to go shopping, but at the moment I just do for myself. February coming I'll be 102. I've noticed that from when I was growing up, during my school days, I've always been healthy, and when I was back home I never had any shoes, I never had many clothes and I've had to work hard for my daily bread. I never went to any university, but I had a good schooling and I learned enough to keep me, and show me how to live among people (phone rings). "Hello. I'm fine, I'm fine... Champion man... I'm just right here... Your dad is fine." The family is very good to me, they come around and I'm kind of, contented. Yes. I thank God for every day, I'm contented.

I feel good, I am not suffering any, I am not bed-ridden. I can get out and go. I am enjoying my life. I know that one day I'll have to go. You must go! And I know that, but while I can manage to move around and do for myself, especially if I can make my tea, make my toast and make my soup and say my prayers and go to bed and wake up in the morning and still get up and make my breakfast. I don't wait on anyone to come and do. I'm quite content that way. I get my little pension. I go to the bookie. Ladbrokes gave me a party on my hundredth birthday, then I had a party in the Hibernian Social Club with over 300 people there. I think I integrate so well with the people, that's what helps to keep me going. When I came to Edinburgh I didn't find the people prejudiced. I'm quite happy to integrate myself among them. I'm well known throughout Edinburgh. I never sit down and feel depressed; feel lonely. Life is too short for that. You only have one chance. You got to live!

Anne Meston

Born 12 November 1903

My birthday is 26 November!

Grandson Keith (K): No. 12th of November Gran.

No! That's the day I get my birth... Well, all right.

K: 12th November 1903.

OK. He's the boss. I'm up here for a holiday with my lad. Do you think I look 100?

I don't think so, but I don't know what somebody who is 100 is supposed to look like.

Yes.

Can you still walk around alright?

K: Yes she can, yes. You can walk around still.

(She grabs a stick and gets up.) Walk around. What for? That's what I'm wondering about.

K: OK Gran. Sit back down.

When shall I see the result of this?

If you want I'll send you a couple of prints.

Yes, that would be nice that.

Did you have brothers and sisters?

K: Gran, he wants to know about your brothers and sisters.

Well my brothers and sisters are lovely.

How many did you have?

Well I had three brothers now, and five sisters isn't it?

K: They're all passed away. Sometimes she thinks they're still alive.

There is any amount of them.

Can you tell me about how you met your husband?

Now I don't think it was anything in particular. He was doing something about the stage. And that was how I came to meet. I think that was it.

He was an actor?

Yes. Who is this?

Your husband.

Oh yes. No he wasn't an actor, no.

What did he do? What was his job?

He was in the business. Tea business.

K: Second husband. First husband was a scientist.

(Points to a picture) There's my father's ships! And there's my family, my whole family. We're all Brixhamites we are. There's only me left.

Did you like sports?

K: She was a bookworm. She was top of the class in everything. Used to love taking exams.

Do I what?

Like sports.

Oh yes! I don't work it you know. I like to play tennis but, I didn't do much.

So do you still read books?

K: No she can't. She's got the cataracts.

I love singing! And the thought of singing fills me with joy! But I've never sung on the stage. Only the little private stage. But never on a proper stage. I could try. And I could sing couldn't I Keith?

K: Yes you could Gran.

Oh well. I sang in the schools you see. So I didn't really go in the church or that. But I went to the school. What do you call my school Keith?

Do you have a good singing voice?

I sure do!

K: Sometimes two o'clock, three o'clock in the morning she is up, you can hear her singing in the room.

Can you sing something to me?

Eh?

Can you sing something Gran?

Oh sing!

(Singing) Oh dear what can the matter be? Oh dear what can the clatter be?

Was that all right? (Laughs) Well I wasn't prepared with singing. But I can sing!

Well you seem to enjoy life still.

Yes! I do indeed! Yes. I've got a nice companion you see (indicates her grandson). He's a big fella so you've got to be careful.

And, you like to go out in the car?

Yes I do. I love it. I love it, don't I Keith?

K: You certainly do Gran.

So you feel you've had a good life then?

Yes. I have. A happy life... That's a nice photo of me isn't it? There, I'm not bad really. Then there's me with my grandson. See him? He's a big 'un. He's here (points).

Do you have a secret? What has kept you going?

Oh yes, I did have a sister.

No, secret!

A teacher?

K: Gran. Gran, how have you managed to stay this old?

I'm a happy person. I know. I got my lad here to look after me, Keith.

Do you believe in an afterlife? What do think happens after you die?

What can happen to me? Well, I don't know, I've never given that much thought. I'm just happy while I'm here and wait for that. It's no good thinking about it. I just read the Bible, listened to the sermons and I think if you live happily, you give it. Don't you love? Yes. You love and you get it in return.

Thank you very much for talking to me.

Have you enjoyed it?

Yes I have, and it's good to see that somebody your age is so lively still.

Yes. How old am I now?

K: You're going to be 107 in about two weeks now.

Yes, 107. I don't believe that mind you, but I've got to because he says so. But it's pretty good going!

Alice Herz-Sommer

Born 26 January 1903

When we are old we are aware of the beauty of life. Young people take everything for granted. We know that life is beautiful. We know a lot and we are conscious of this and this is a beautiful thing. It all depends on the character you're born with. The character... In my case I... I forget! Everything I forget. Even if I write it down, I forget to look! Ah, I forget! Our brain is a miracle. We never know what is happening there. Absolute miracle! I had an excellent memory and now, I'm an idiot (laughs). What I do against it? I learn Bach by heart. Bach, yes. Not Mozart, not Beethoven. Bach!

You're still playing the piano now?

At 10 o'clock in the morning it starts up (laughs). And people in my house, "Ah, it's 10 o'clock!"

Your son is a cellist?

He is not any more. He died at the age of 64. We are not old when we are 64. He was a very gifted musician, and a wonderful son. My only child.

And your husband was a violinist?

No, no. He was a businessman. But very, very musical. His family came from Vienna. We have in our house, twice a week, quartets, four people playing. Full of music! Full of music. Music is, in my opinion, the most beautiful thing coming out of mankind. It is a mystery.

Despite your experience in the (concentration) camps, you are still optimistic?

It was very bad. I am one of the survivors. Mrs Zdenka (indicates her friend) as well, and this is something extraordinary. Thousands and millions that had to die, and we are sitting here, and every Sunday we are together, and have a beautiful time.

So even that you can put behind you?

Ya. Ya. Ya. Absolutely!

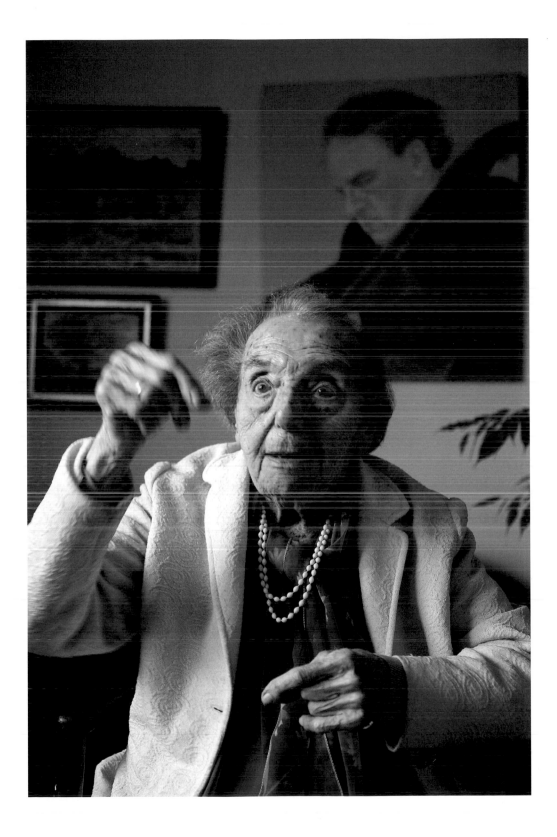

Betty Stobbart

Born 14 October 1910

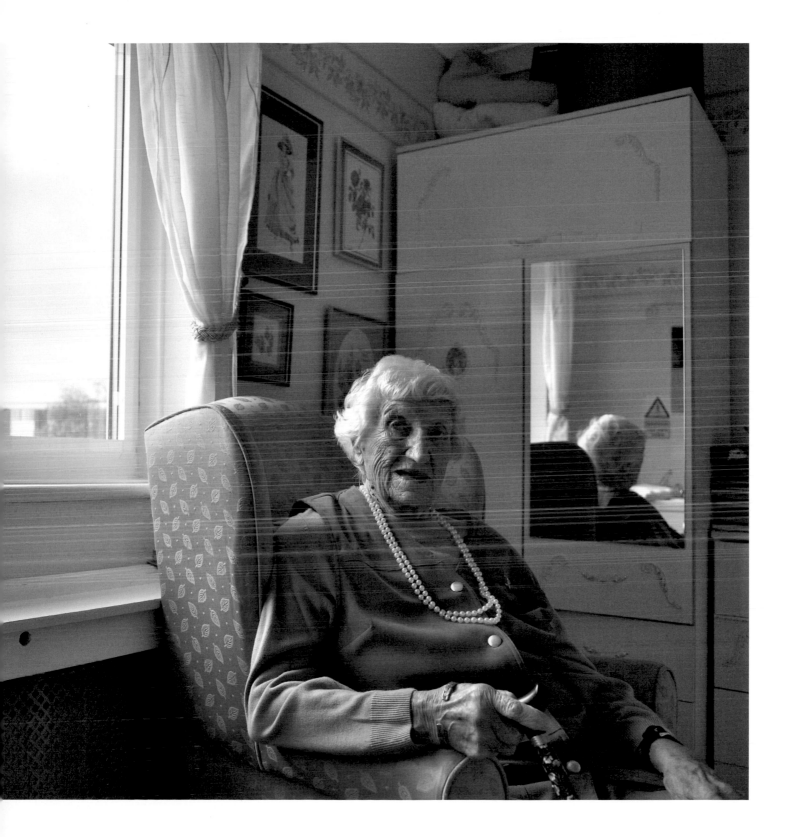

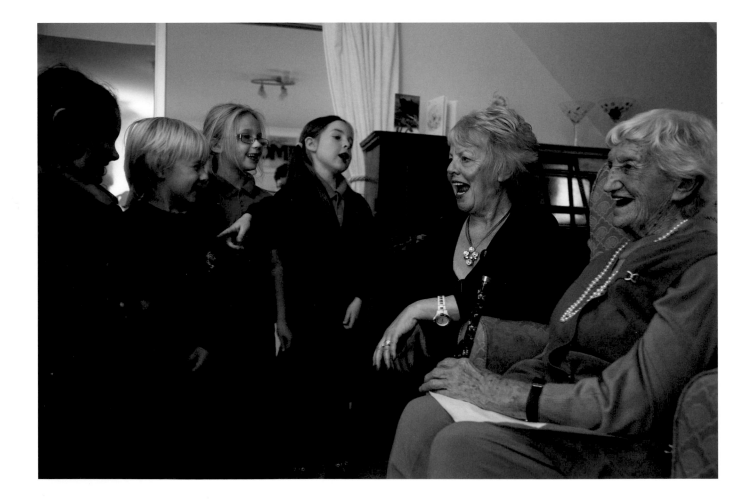

I've just been in here about a year. I wasn't very well and the doctor advised me he said, "You've looked after everybody." I said, "Yes I have" and he said, "Well it's time somebody looked after you." I took badly to it at first you know. I like to be out, I loved the fresh air and my dad did as well. I think myself that it's fresh air that's kept me going. That's all I can think of... I've got osteoarthritis. It came when I was 60 and it went away, so I didn't bother with the operation, I've been lucky, but it's just come back now. It's come back to my hip and it's all swollen. It pains terribly. If you don't get one thing you'll get another. I'm not perfect by a long way now but I'm lucky, very lucky, that good health stayed with me till now. I'm very thankful for it... I've got friends in here, but it's nice in here and Leslie (care worker) that I love very much, she is in the kitchen right now because it's the cook's day off... I'm a person who don't give in like some. Some get in here and just drop. They think they're dying, but I've never felt like that. If you got a nice friend like what I've got it helps a lot. But I've managed to make 100 anyway. Is that what you've come about?

Yes that's it. I'm wondering how long you feel you want to go on?

I'm ready to go. I'm ready to go now.

Care worker: "Don't say that!"

Don't say that? Lovely little girl she's kindness her own self! My dad he was wonderful and he went just the way I want to go. He lived to 104 but he wasn't crippled like me. I'm crippled you see. He had the flu and the doctor said to me, "Betty, I'm afraid I cannot help your dad any more. I've done my best. I don't think he'll get better." "Thank you very much doctor, you've been very kind."

(Later, to visiting children). They're all lovely aren't they? You never slipped up once did you? I think you're very clever!

Kids singing: We'll meet again, don't know where, don't know when but I know we'll meet again some sunny day.

Rena Ward

Born 18 November 1910

I read in the papers that you had your fortune told when you were small? What did they tell you?

A load of rubbish! (Laughs).

Daughter, Pauline (P): I thought they told you that you were going to live till you were 100?

Yes they did, they told me I'd live to be 100. That wasn't rubbish, it was right and I still lived to be 100.

P: So how many more do you think you are going to have?

I don't make predictions like that because I'm living too long! I don't dream about getting old!

What do you dream about?

Just daydreams.

About dancing?

Yes, that comes into it. Yes, I loved dancing. I never had lessons, I just danced. From the age of ten. I was that high (gestures at the level of her knee) I was 8 years old. I loved it. I danced till I was, what? Old.

P: Into her nineties.

Five days a week, dancing. I loved it! I dance around the house, I dance here (laughs), dance around (Pauline shakes her head).

You mean you imagine you are dancing?

Yes, I move my hands or I move my feet around. I daydream about dancing, I dance in here. It was my passion.

Did your husband dance?

No, he'd go off somewhere. I tried to teach her (indicates Pauline) to dance but she wouldn't. I loved the old fashioned dances, we called them old fashioned dances... I am lucky to be 100. I still enjoy life. I love to be occupied.

How do you occupy yourself now you can't go out dancing?

Talking! I like to talk (Pauline nods).

When were you happiest?

Oh! At my home with my mother and father. I loved it at my home!

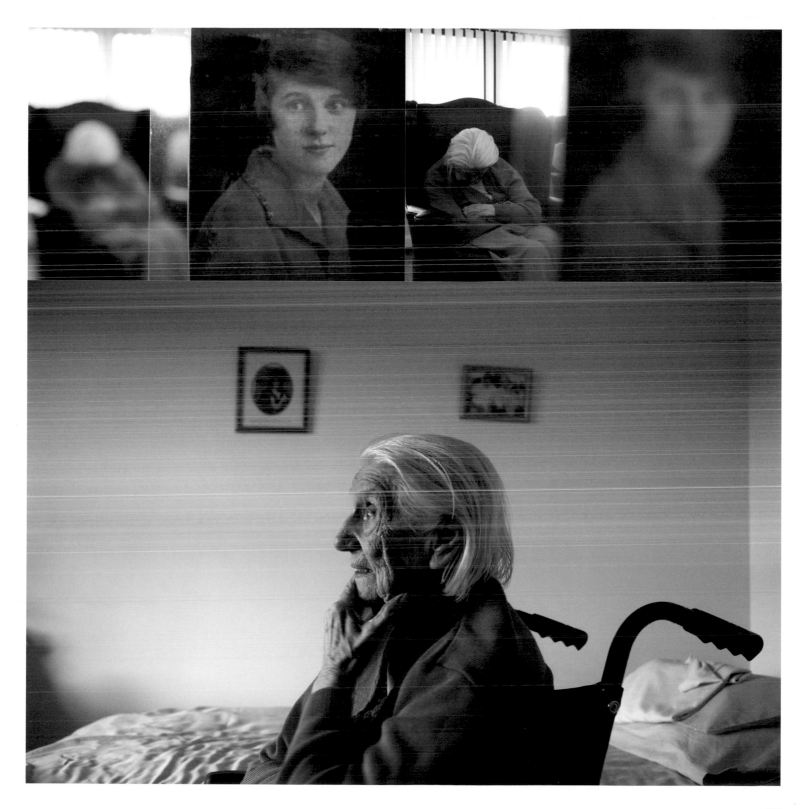

Ira Parsonage

Born 18 September 1907

How old are you now?

I'm 98! *(Actually 103)* 98!

(Shouting) Can you hear me alright?

Yes.

What work did you use to do?

Work? Drilling. For John Thompson's Steel, I used to drill steel. In a factory.

Did you like the work?

Well, it was a case of having to like it.

Did you do that all your life?

I was a driller all my life.

What age did you leave school?

How old was I? I was 14.

And what about your family? Did you have brothers and sisters?

I had two brothers and three sisters. I was the youngest of three sisters and two brothers. I was the youngest.

Did you get married?

Yes. I got married and lost the wife! I lost the wife. The wife died. I wasn't married long before she died. Not very long. I can't really remember, but it wasn't very long. More's the pity.

What about children?

Two brothers and three sisters.

No, I mean your own children.

Two daughters. Yes they were all mine. I was the father.

Do they live around here?

Around Wolverhampton.

Do you see them?

(Long silence) I don't want to talk about them. I lost them. I don't want to talk about them. You must shut up! (Long silence).

Do you enjoy sports? Do you watch it on TV?

I like to watch television.

Do you have a favourite?

No, I like them all. I like them all.

Do you like reading?

Not a lot. My eyes are not too good (pause). Now shut up. I don't want to talk again!

Tessa Grimes

Born 3 August 1910

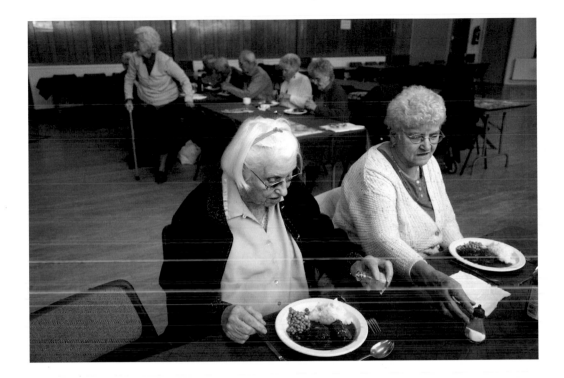

Did you have a party when you had your birthday?

Seemed like we had four parties! We had one here for Tuesday. We had one for Thursday. And then my son and daughter got me a big one to go out with all the family together. I got a card from the Queen and a picture, and a card from what's his name? Iain Duncan Smith. I don't know who he is... I had two brothers and one sister. My sister is 96 but she's very poorly. She's in bed all the time and it's hard work for her daughter. That's what I'm afraid of, that if anything should happen to me, my daughter is in Birmingham. I'm just thinking I'm getting on very well, I don't want to go on too far, because my daughter will be 70 in December. I don't like her coming down looking after me (because of the drive). My daughter usually stays through a week if she comes. She stays with me, I've got the chair she can sleep on, but of course my son, he'll be in tonight, he comes in for an hour. Tuesdays and Thursdays he comes, and takes me shopping on Saturday's. If I want anything he'll do it.

How do you spend your time?

Very lonely! Because I don't go out much. Can't go out much. It takes all the time cleaning up my place, getting my meals. And I like reading. I don't do much television. News. I put the news on. I've got the radio but I don't use it. I can't hear it as my hearing's not that good. I read anything I can get hold of, novels. I don't mind history. One thing I couldn't understand is what Moby Dick... It's supposed to be a good one, but I can't make any sense out of that one.

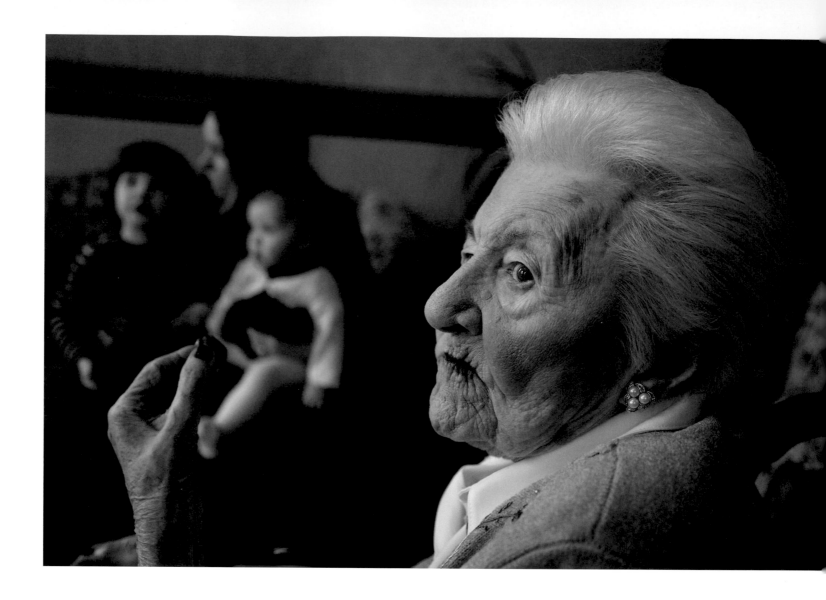

Dorothy Williams

Born 10 February 1911

Her family provided this information.

Dorothy was born in North London and had to help her mother look after a large family. Her father was wounded in the First World War. She left school at 14 and worked in an aluminium foil factory where she met her future husband, Billy.

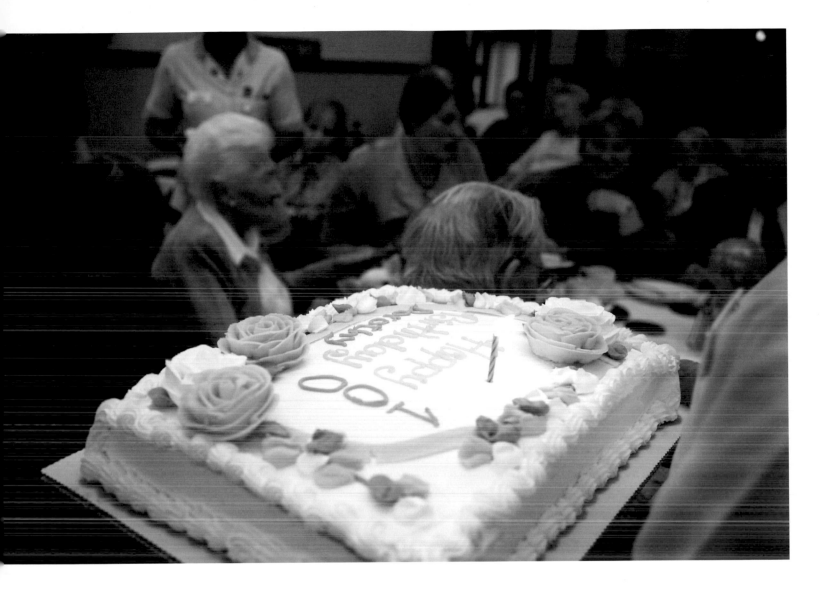

She lost her brother Reggie in a car accident and her sister Gladys
to tuberculosis. Dorothy also contracted tuberculosis and was sent to
Switzerland for a cure. She learnt French and developed an interest in travel.

She married in 1939 and her husband was called up in 1942. She ran a
business making dolls' heads and in the evenings worked as a fire-watcher.
She had one son, Michael and now has 3 grandchildren and 3 great
grandchildren.

She enjoyed painting and jazz and used to play the piano. Her husband died
in 1972 and after a fall Dorothy moved to a care home when she was 90.
She still enjoys playing Scrabble.

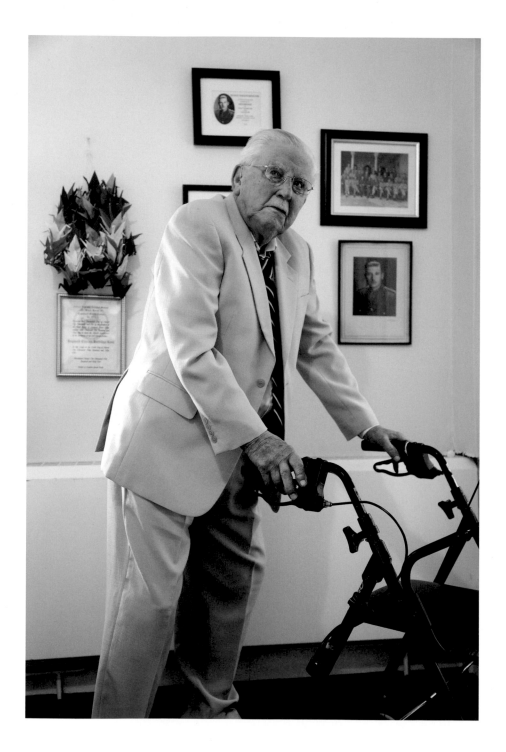

Reginald Gore

Born 15 January 1909

Your birthday is coming up and you'll be 102 then.

102 coming up. Oh I see, yes, that's right 102. Yes, there you are, managed to stick it out. I feel pretty well. They look after me here. I've decided to stay here, for a bit anyway (laughs). No, they are a lovely lot, especially this dear lady here (indicates carer). Yes.

Now that you are over 100 how does it feel?

I feel pretty well actually. Yes, I've been pretty lucky. What am I? 200 did you say?

Daughter, Diana (D): (Laughs) That's right dad.

I've knocked around here quite a lot and I love it here, for argument's sake, and love around this area... And my parents. They were both marvellous, but she (mother) was in particular.

Did you have brothers and sisters?

Did I have brothers and sisters? I had my sister. I had two sisters didn't I? It's two sisters isn't it?

D: No, you have one brother still. You had little Daphne who died when she was not much more than a baby and then you had Eric who is your other brother who died in his twenties from pneumonia.

In his twenties? My brother was only in his twenties?

D: Yes brother Eric was only in his twenties but you've still got Uncle John, your brother John, haven't you?

Oh, of course yes. That follows. I've followed now.

Care Worker: Reg. Swallow your tablets please. Oops, you missed one. There you are. One more please. You chew that one. May I give you your eye drops Reg?

Go ahead. Thanks very much.

Do you have any idea why you've lived to such a great age?

I haven't to be honest. I have lived to quite a good age that sort of thing. I've had a fortunate existence personally. I've enjoyed it looking back on myself, I've been happy. I remember of course when the... Well don't I remember when the Second World War started?

You were in it. You were fighting in it.

Yes, that's right, yes and of course I've lived in the area for a long time, and I've lived amongst the local people here... I was in Lloyds Bank. Yes... I'm sorry I keep forgetting what I was going to say.

Have you set yourself a target of how old you want to get?

Oh no. No I haven't set targets of that nature, except just to say, "Tell him to wait!" (Laughs) There we are.

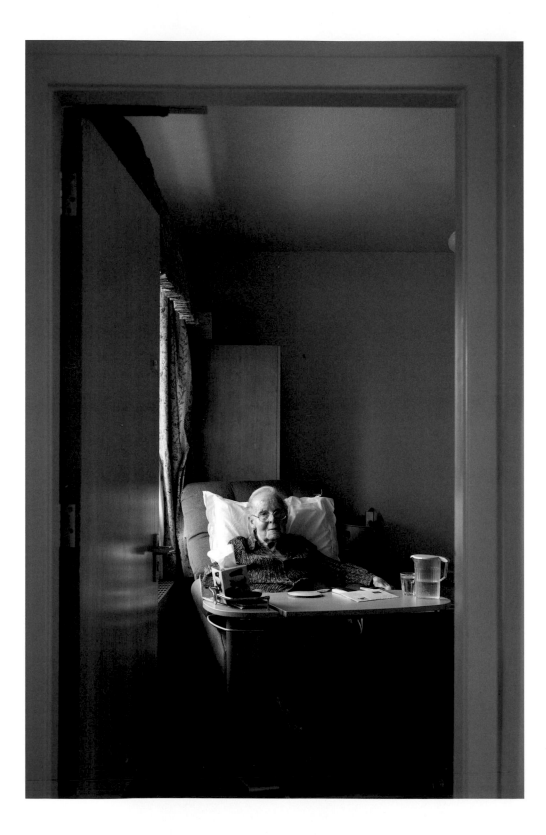

Sheila May Hall Horsbrugh

Born 8 November 1909

I was an actress for many years. It all developed you see, television, radio came in and there was nothing like that when I started. Then these new things came in and, so it developed from there.

You did TV as well?

Yes radio, TV, anybody who would employ me (laughs). I'm very lucky that I have the mental ability I have, but there are great gaps in it. I was 80, so I seem to remember, when I retired from everything. I was only doing voiceovers and things like that at the end.

And did you enjoy it?

Loved every minute of it! And my generation, well, it was shocking because my father was a very well-known doctor and I should have been a debutant, and had a ball, and hopefully picked up a husband, because that was the whole reason of it (laughs). So the families could get rid of the daughters, they didn't think much of daughters. They all wanted sons.

Your husband was an actor?

He was an actor, yes. But in his day, a stage actor. He did eventually, when it came in, he did quite a lot of television. I met him at a summer season down in Bognor Regis. Nine weeks in the summer and I met him there. And, um, that was history!

How long have you been in the home?

Not very long. I think my diary will tell me (searches for her diary). Aah! There it is. 27th of January I left hospital. Moved to Hatfield House... I was living in my own flat with my own carer, but then I had a heart attack, and I couldn't continue where I was because there was only coverage at mealtimes. There was no coverage during the day and no coverage at night. Caroline found it, my daughter-in-law.

How are you feeling now? Are you feeling better?

Well, I'm sort of amazed that I do feel better. But I mean, I don't make any efforts about anything. If I drop something on the floor I ring a bell and somebody comes in picks it up (laughs). No. I mean, I think my time is over. I think it was over years ago. I have no pleasure in living as long as this because I can't really do anything.

You feel that your time is really spent now?

Yes, I really do think so. I mean there is no history in the family of longevity at all. My mother was in her 50s, and my father just made 70 and that was considered quite good... My hundredth birthday party last year, it was absolutely amazing because they all came, from various parts. From Wales, from Scotland, from Germany, from France. And it was a day to remember, it really was!

But that doesn't keep you feeling, "I want to go on"?

No! I mean I can't do anything I want to do and I have to have carers, you know, and rules and regulations, and pills and goodness knows what. It's no life. No life at all. And I think anybody in my position would tell you that.

How do you see the future now?

Going to bed and not waking up. I think that's the solution. Doesn't cause me any trouble, doesn't cause anyone else any trouble.

But you still enjoy some things, I see you have books by the bed?

Yes I read quite a bit and there is the old television.

But how is it here as far as the place goes?

Oh yes, it's very nice. Absolutely ideal. No, I'm very lucky because they allow you to be yourself if you see what I mean, because in so many places there are so many rules.

Do you have strong religious beliefs? Do you think of yourself going to Heaven or something like that?

No, I believe Jesus was a good man who wanted to help people, but I don't believe he is the Son of God. I don't believe I will live on, except in people's memories, but as I have great grandchildren it'll go on for quite awhile.

Is there a way you would like to be remembered?

It seems odd to say it, but I'd like people to remember me as somebody who talked sense and yet could laugh at it. Yes, I'd like to be remembered as somebody they liked. It's been a long life, I've enjoyed it, but it's over now. This old thing should stop beating, it's been doing it for long enough.

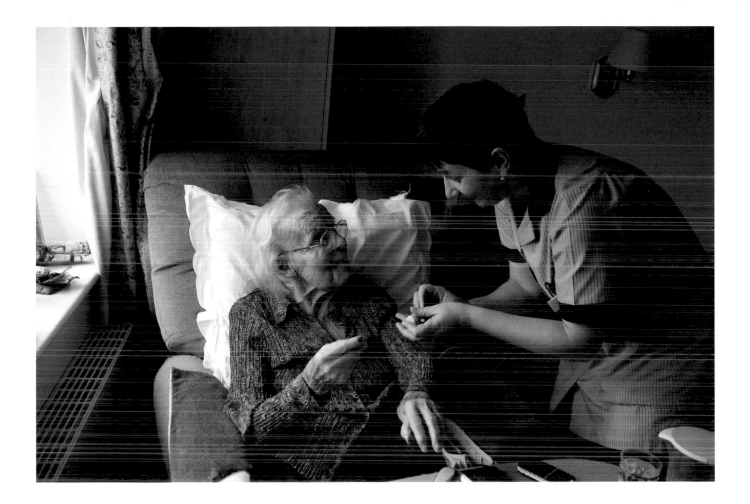

Annie Winifred Cotterull

Born 17 February 1908

How do you feel?

Very good. If only my legs were all right I'll be able to walk.

Care worker (CW): Are you all right Queenie?

Yes.

CW: I will be back soon, I'm going to collect people for your party.

I have four children. The eldest one died a little while ago. Three girls and a boy. They all live a long way away, and they all work you see, that's the trouble.

Your legs give you some problems?

Well, when I first came here they dropped me, and the man he had been drinking. I don't know, and he dropped me and I can't walk on this one, but somebody said that if it was properly manipulated it would be all right. Well I can't help it can I?

But apart from that how are you?

I'm all right. I can't see, but then, not very well.

Can you see me? Do you recognise faces?

I see so many, I don't know. I could before but you see so many different ones, you can't remember. My memory is fairly good. I can talk sensibly and I can reckon and all that.

How do you feel about being 103 do you have any special thoughts about that?

It's funny because I can do so much, I feel so well. I'd be happier if I was on my own but the doctor said I couldn't live alone. So I been in here for years, I've got used to it.

Do you have any idea why it is that you have lived so long?

No idea at all. I've had to work. I was an only child. I was always on my own.

Do you have any target in mind like living to be 105?

No, I'm quite set. I think it is wonderful, and they look after you well. Sometimes I get a bit bored. I'm on my own a lot, but comparatively speaking I'm all right (laughs).

Do you have friends here amongst the other residents?

No. I don't mix very well. I'd like to be able to read! But I can't any more because my eyes.

Daughter (D): Mother!

Your daughter is here.

Oh, that's good.

D: Happy birthday! (Kiss).

Have you come on your own?

D: No. Derek's just around the corner.

Constance Roberts

Born 28 February 1911

My full name is Constance Elsie Ellie Fanny Roberts! I had two sisters younger than me but they both died. So it's me, only me. My husband died quite suddenly. I was 60 when he died. He was 62. I have one daughter who looks after me. She does most of the shopping and cleaning.

Where did you meet your husband?

I was in an aunt's house and he came in, he was a butcher, and he was bringing them meat, and we started going out together. He was a butcher and when the war started he went and volunteered in the merchant navy. Some tough times but he was all right. He went back into butchering... then one day I was at a friends and he rang up saying he wasn't feeling very well and he'd sent for the doctor and the doctor got him into hospital. Wasn't too bad, he was there about a fortnight and I was picking him up after work, and they rang me up, and he'd died. So, that was that. It was 40 years ago. I've been on me own ever since. I worked 5 years after that and then I retired. I was 65.

You live here by yourself?

Yes. I go to the luncheon club three days a week, Monday I go out to play bingo and Thursday is Woman's Guild, every fortnight. We meet and have a talk. The last talk was on Rwanda, the people of Rwanda. A fellow went out there with a group. Very interesting. Keeps me going, keeps me going, yes. Oh! I knit, I knit little small things. I give them to fairs and charities and that, so, my fingers are fine, more or less. Yes, I'm just doing a blanket now.

(To daughter Anne) How often do you visit?

Anne: The days that mum's not out! (Laughs). I come Thursday, Saturday and Sunday. Knowing she's out gives me a rest. She's out with people and has company. She has a better social life than me!

Yes, next week, Wednesday, Thursday and Friday I'm having Christmas dinners. Yes.

Have you always been quite active?

Yes, I think so. I was a teacher. I can't walk too far now. I have a stick and I can walk to the road and back again. Then I've got a wheelchair and Anne takes me out to the village sometimes.

Does being 100 mean anything special to you?

No. No. Except everybody said, "Oh, she's a hundred." They make a fuss of me. But, no different. People ask me why, but I just say, "No, don't know." Just carry on.

Are you still enjoying life?

Yes, oh yes. Just a day at a time. Keep going. Travelling, holidays and that. You miss those, but I get around all right.

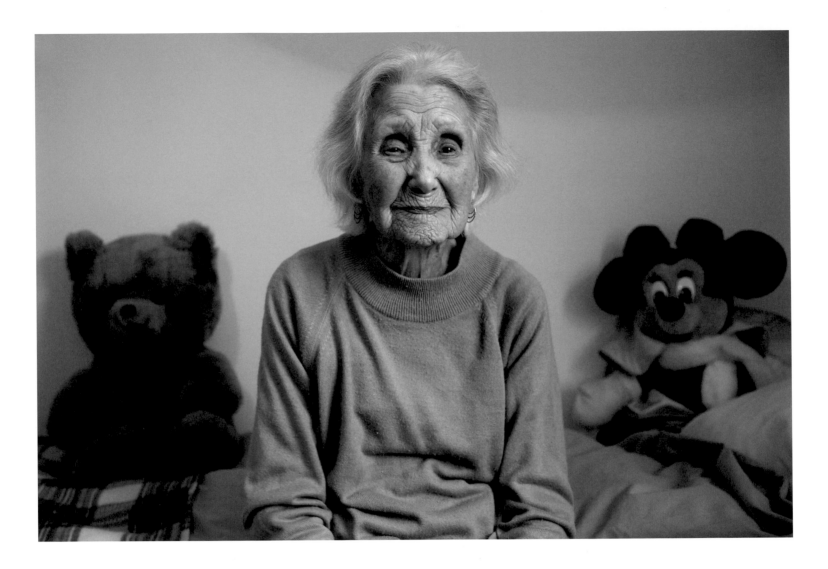

Hilda Young

Born 23 April 1908

What work did you used to do?

I was in the post office. Nothing to be proud of.

No that's fine. Did you work your whole life there?

Well, since I left school and, before I left school actually. I liked it there though, it was quite good. Interesting. My father worked in the post office since he left school. Still works in the post office. Yes, I enjoyed it.

And did you get married?

(Shows wedding ring). Yes. Yes, that's why I've got two sons!

Do you think you've had a good life?

Yes. I thoroughly enjoyed working in the post office. Yes. Quite interesting. Yes. Oh yes I thoroughly enjoyed working in the post office, really. Both my brothers worked in the post office too. They worked on the telephones. Yes, they both worked in the post office.

Care worker (CW): Hilda, did you sing in the choir for 20 years? She loves cats and she likes gardening.

Well people run it down sometimes, the post office work... I bet my dear old mum is wondering where the devil I am! 'Cause if I'm not home by 6.30... I ring around if I get a chance and tell her... I'm alright but, there we go... My father still works in the post office.

CW: That's nice.

Yeah (looks out of the window)... Somebody's let their pigeons out!

Are you still happy now?

Well yes, I think so. Sometimes it's all right and sometimes it's not. It's hard work, in the post office, you've got to learn such a lot before you can say you've done anything.

Now that you've passed 100, how long do you think you will live till?

Oh, not too far. I don't want to get too old. Life is quite good really. My mum and dad are top-ho really, they're two of the best. There you go. Life is what you make it isn't it?

Mary Sturman

Born 15 December 1910

Do you go to bingo every week?

Sundays.

And are there any other things you do regularly like that?

Not really, I have them puzzle books to pass a little time on, them word searches, and I've been doing craftwork. I used to do cards in home at one time, Christmas cards.

When you were younger what work were you doing?

All sorts, I used to work at church cleaning, and the house where the priest lived. I worked at Claremont cleaning while I worked at Bassett's, Liquorice All Sorts, stoning cherries. Doing three jobs in one day really.

Do you have a time of your life when you feel you are happiest?

I don't know. I'm happy enough. I'm not ready for going, I'll put it that way! No, I don't feel ready for going. I don't want to rush me life on, you know? I want to stay here as long as I can. When the time comes, it comes! You can't do nothing about that. I'm not miserable, I don't grumble a lot. No, I'm not ready for going. When the time comes I can't do anything about it. We've all got to come to it haven't we?

Are you religious at all?

I'm Catholic. I keep up with it as much as I can. A nun comes and visits once a week... I'm not lonely, I'll put it that way.

Daughter Winifred (W): She likes it when the family comes, especially her granddaughter, they are like that (makes clasping gesture) them two! (Laughs).

Yes. I think that's it, isn't it? If you can stop being miserable.

W: She's very independent.

Have you got any favourite television programmes?

Oh, 'Coronation Street', 'Jeremy Kyle'. Oh, love 'Jeremy Kyle'! And 'Corrie' and 'Emmerdale'!

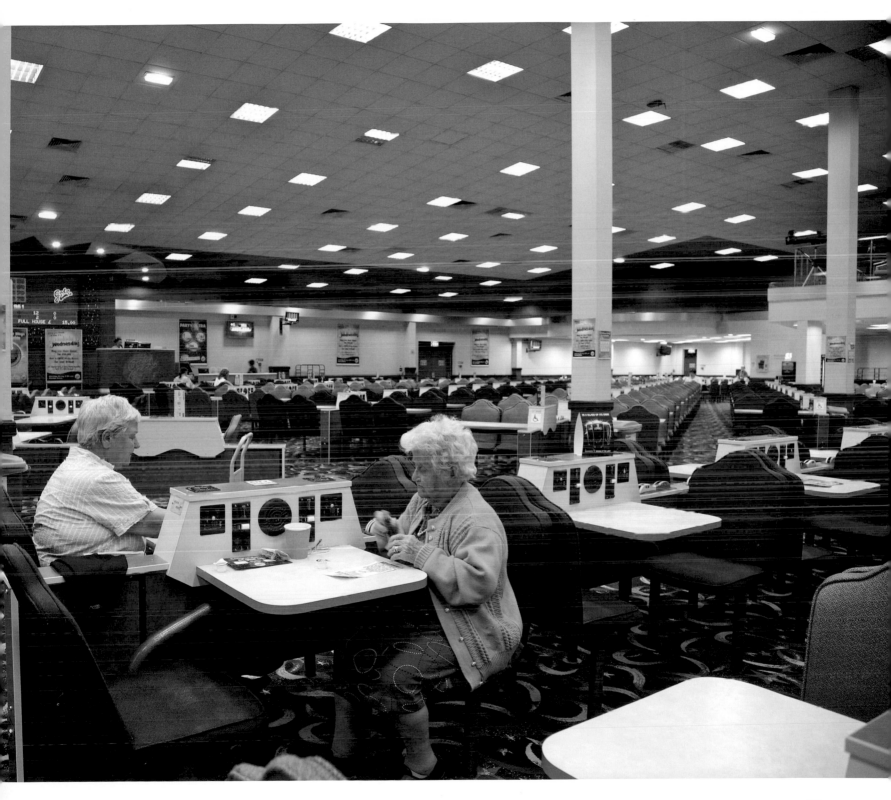

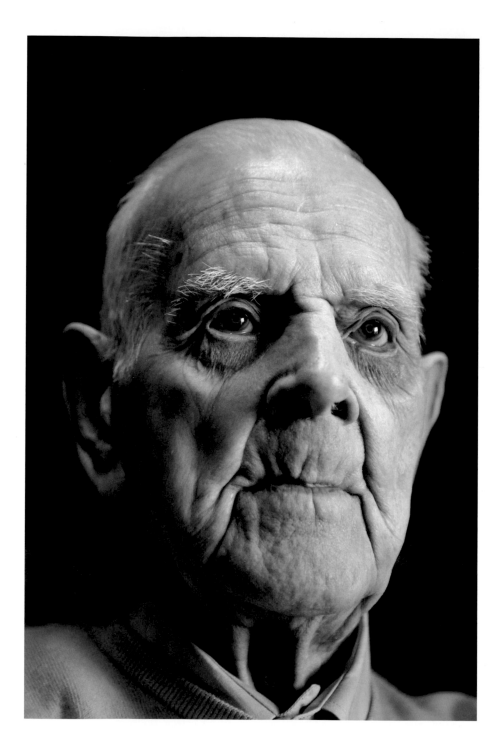

James Hardware

Born 25 November 1910

Key worker (KW): (shouting into his ear as he is very deaf) He doesn't believe he's 100. He's going to take your photo. Look at the camera.

James?

KW: He's going to take your picture.

What's it for?

It's for a book.

What?

KW: Tell him about the farm when you were a little boy. (Long silence). He's thinking. Tell him about the farm. You worked on the farm.

Yes I worked on a farm. It was a long time ago.

KW: You grew up in Tettenhall. In Tettenhall. You grew up in Tettenhall (silence). Tell him about your brothers and sisters. You had a sister, Beatrice.

Eh?

KW: You loved Beatrice. What about your brother, your two brothers?

What?

KW: Your brothers! You've got two brothers. Billy. Was it Billy?

I don't remember that.

KW: You do!

I've got nobody.

KW: Yes you have! You've got me (to me). He's got no family left now. Do you remember Billy?

(Silence).

KW: He'll tell you about when he was in the Royal Artillery. Were you are in the Royal Artillery?

What?

KW: The RA.

(Silence).

He's not hearing.

KW: You went to Germany.

I went to Germany, yes, during the war. I was in charge of the troops.

KW: Corporal. He never married. Were you are in the army a long time?

Oh, I can't remember. A long time ago... I went to Belgium and to France during the war, and then to Germany.

KW: And then you came home to England. Did you work at Courtaulds?

Yes I did.

KW: What did you do at Courtaulds? (Silence). He used to deliver fabrics to different places.

I was in charge, you know, my group...

Were you a Corporal?

I'm trying to think. I used to have, motors...

KW: He loved motorcars. Did you used to have a Jaguar?

Oh, I may have had one.

KW: You've had a good life!

Quite alright. Honest.

KW: He likes singing. Sing me a song.

(Laughs).

KW: Tell us a joke?

No... I can't remember.

So what is your favourite song; the one you like to sing?

(Singing). It's a long way to Tipperary... That's not it.

KW: (Showing photographs of him as a young man). Who is that?

Me.

How old were you then?

I can't remember (Long pause). I was in charge, of the troops... Germany.

KW: You are a good soldier! I'm very proud of you. I love you!

Eh?

KW: I love you! (Silence). Do you love me?

(Laughs).

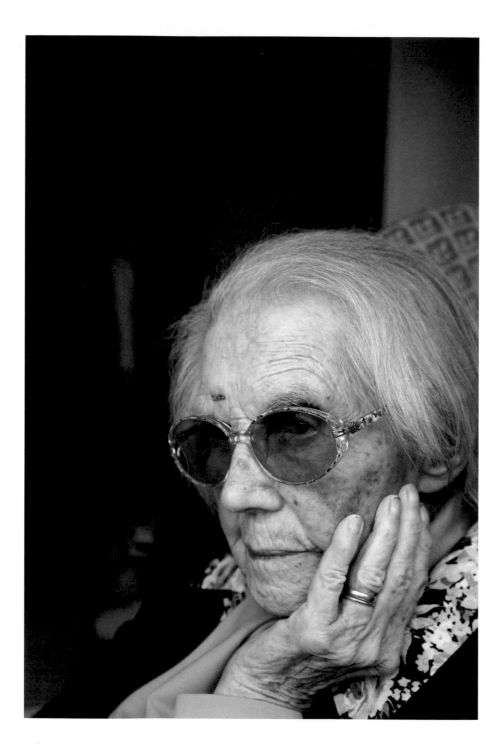

Victoria Roberta Southan

Born 24 May 1900

Care worker (CW): (To me) You'll have to bend down and talk to her ear-hole if you want to talk to her.

Can you hear me all right?

I can't hear very well.

Can you hear me now?

Yes, just about... I was born on Queen Victoria's birthday in 1900, and they christened me Victoria. That's how I got the name.

Have you got a middle name?

Roberta, my father's name was Robert. He wanted a boy, and when it was the girl he said, "We'll have Roberta," so I'm Victoria Roberta. What a mouthful!

Do you have any brothers and sisters?

I've got a daughter. Son-in-law. My brother died and my sister, and, let me see, she died too, very early in life.

Do you remember much about your childhood?

Yes. I left school when I was 12 and I got to go to work because Churchill had been to Germany and said there was going to be a war, so I was sent to a little factory where I got to do the bullets, and I couldn't reach them so they had to fetch a block of wood to set me on, and we worked eight in the morning till six doing this. The foreman said, "Are you sure you've got your certificate from school?" And I said, "You turn around and I'll get it from my knickers." (Laughs).

After the war what jobs did you do?

I know I had other jobs. I went to a nursing home. Worked at a nursing home. It was quite good because the ladies there had got a bit of money, and they used to buy me chocolate bars. When I left school I thought I was going to the grammar school but my mother said, "Can't be any grammar school, you've got to go to work."

Was that a big disappointment for you?

It was. Still, I knew I was doing the right thing because I had to help the war.

How many children did you have?

One. One. A daughter.

Are you living in your own house?

Yes. I've got a granddaughter that works quite a bit and then comes home in the evening, but she's got a nice young man, they may be getting married in a bit. But they live very near and my son-in-law comes up and brings the groceries, it saves me going.

What sort of things do you enjoy doing now?

Well, I enjoy dusting all around, cleaning up, putting the backs round, cleaning the place, keeping it clean... Generally two girls come, say, "We're going to give your wash now. Put you to bed." So I go to bed fairly soon. They come about six o'clock, five o'clock sometimes and make a nice tea, then I will wash down and go to bed. Always, I'm in bed early.

CW: She likes singing.

(Singing) Daisy, Daisy I am half crazy oh for the likes of you. It won't be a stylish marriage, I can't afford a carriage but you look sweet upon the seat of a bicycle made for two.

(Long pause).

My old man said, "followed the van, and don't dilly dally on the way." Off went the van with the home packed in it...
And so on. (Coughs) I've got a bit of a sore throat.

Is your eyesight still good enough for reading?

Yes, not too bad and not very good really. I don't do a lot because I have to rest, I put the television on. I like where they play with the balls, snooker. I watched the snooker.

(Showing Victoria a photo of her wedding day). Do you recognise that?

I am not sure. Is it me and my husband? It's a long time ago. Oh my goodness I'm not that good.

You've got another birthday coming up soon, are you looking forward to it?

Yes, because I think we'll still have a little party.

Do you know how old you will be next birthday?

I think, 111, that's right is it? 111. It's too old!

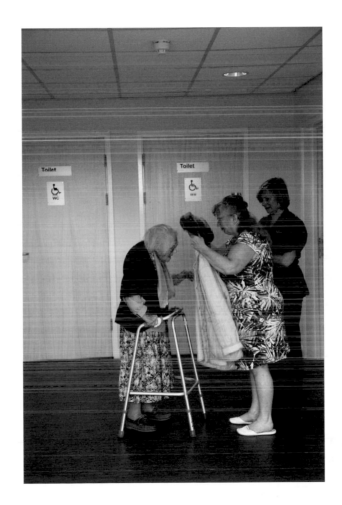

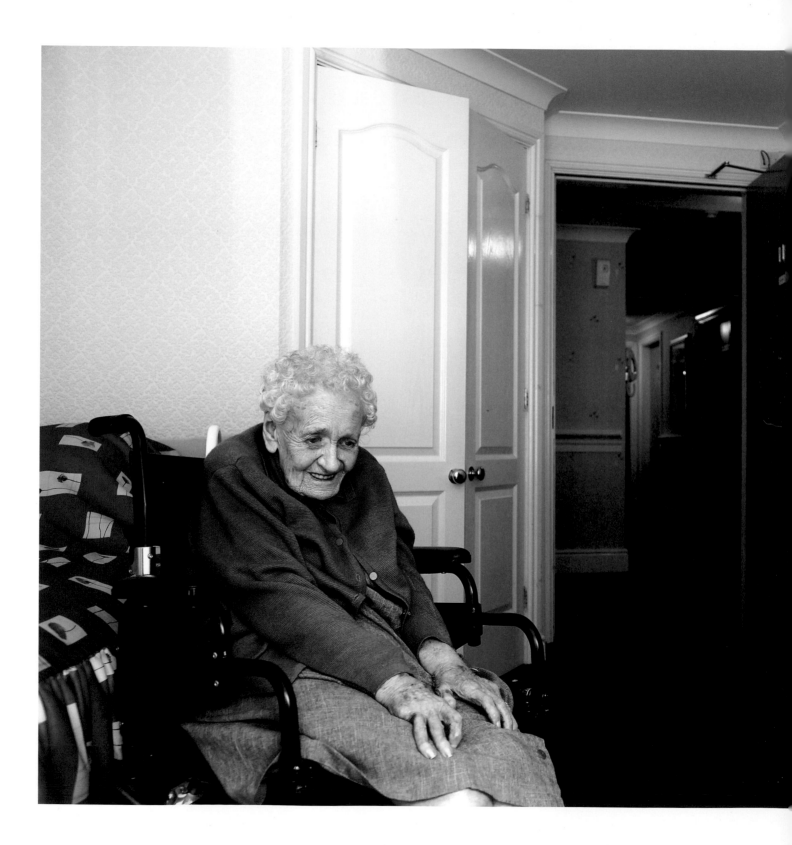

Phyllis Corker

Born 3 June 1907

Do you remember what happened on your birthday?

I don't remember.

Didn't you get a visit from some football players?

I think I did. It's a long time since I went to a football match, but I watch it on the telly. Yes I'm a Sheffield Wednesdayite. I used to go and watch my husband play. He played for Sheffield Wednesday. The blues. The blues. I like them to win.

Is this a photo of you and your husband?

I can't see properly. It looks like me there, do you think so? If he's with me it'll be my husband. That must be me husband. He's not with us any more. Yes I'm sorry he's not with me any more... What are you photographing me for?

It's for a book about people who are 100 years old and you are more than 100 years old.

I'm getting on a bit, but I think I have a good life until now. I've got good carers, they've been very kind. I have been looked after well. My parents were very good, and I've been on my holidays every year. Yes I had a good young life. I used to play the piano a lot, all sorts of things. We had a party. So I had a good life.

And do you remember how you met your husband?

Met him? You're making me think now, it's a long time ago. No, can't remember.

Did you have any children?

Yes. Three. I think there were three of them. They come to see me. It's a wonder they haven't come to see me tonight. They're very kind, very good. They usually bring me some sweets.

Did you have brothers and sisters?

A brother and sister I think. He comes to see me. My brother is a bit younger. I'm the oldest. Too old.

What do you like doing now?

I like watching television and sometimes they put some music on which is very nice. I enjoy Sunday afternoon, they play all Christmas hymns and all that. Yes, I enjoy that. They are very kind to me here you know. What time is it, ten past eight?

Oh no it's 12 o'clock. Do you feel happy nowadays?

Yes, occasionally. You sit by yourself alone and go back a long time; what it was like when I was younger. Now I can't walk. I wish I could walk. I'd enjoy it, if I could walk. Still I've got to put up with it. That's when you're getting old... I don't feel old and I don't feel young, I just feel as though I can carry on as I am doing. And this is my little room. Everything I need is here.

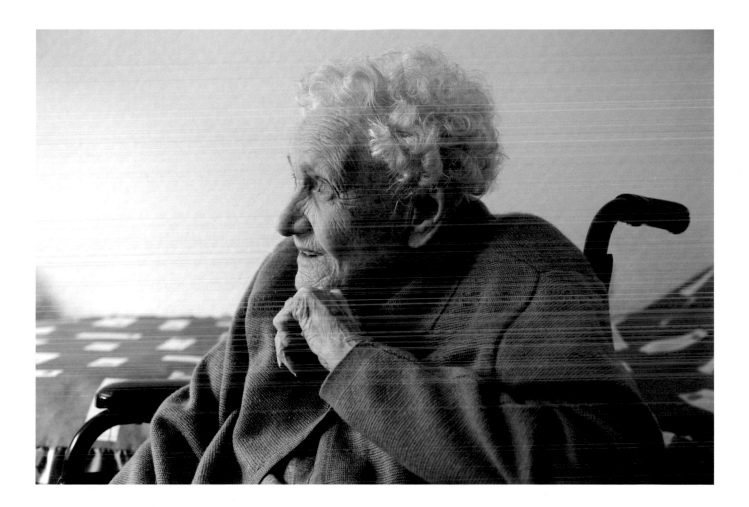

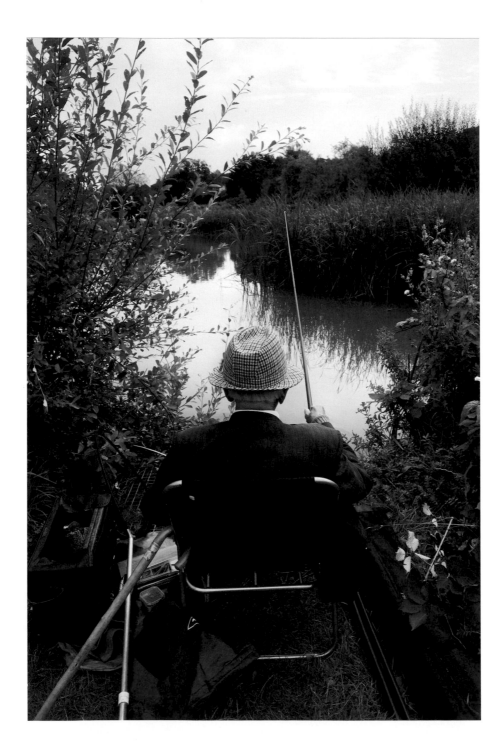

68

William Ware

Born 14 January 1905

I started fishing when I was a boy. Now I go twice a week but sometimes I don't get a chance to go. I drove me own car up till I was 98, clean license and that. Not many can say that can they? I had a motorbike first before I got my car. I was 26. I worked till I was 70.

What work were you doing?

I worked in the building trade first, and then I went into a factory, cabinet-making and then I finished up in charge of the shop turning out thousands of panels. Used to make cabinets, that was when televisions were put inside cabinets, not like they are now and they were sets in a nice bit of furniture in the corner. You open the doors and there was your set. I was foreman there, 30 odd years.

Carer (C): You kept the water hot for them didn't you?

Yeah. I wasn't old enough for the First World War. I was in the second one. I was in the RE's (Royal Engineers) attached to the (pause) oh, words don't come to me.

C: You went to the Isle of Wight didn't you?

Yeah. (Referring to the fishing) The other day I had a good day I couldn't do nothing wrong. Now they're just not coming... Now that I'm old I like to leave here at five o'clock that gives me a chance to get me tea and everything.

Did your wife like fishing?

She used to come with me she never fished.

C: She sat in a chair and sunbathed just like I do.

I've fished from before you ever had to have a license.... I can't make out what's the matter with it!

C: He knows exactly what he's doing.

I tie all me own hooks on. If it wasn't for fishing I wouldn't get out would I? Do me own cooking, make me own bed. Lamb is reasonable and according to my pension, suits me.

C: We do love a bit of cake don't we?

Oh yeah! I like a bit of whisky with my tea in the morning, just a little drop... It's very slow here today.

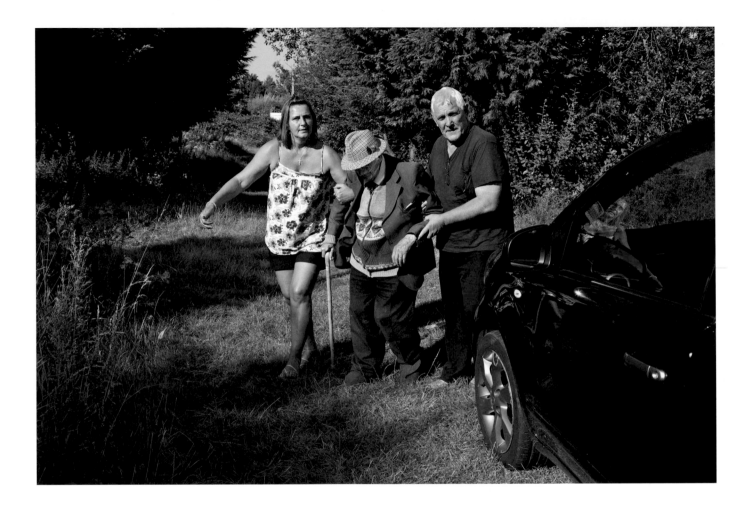

Do you reckon there's any reason you've lived so long?

Keeping on the move. That's the secret. You get a man and a woman, the man gets to 70 and he stops working, and wife still keeps working. Who lives the longest? My wife died when she was 90. We were married 72 years... Are you good at figures?...40, 15, 18, 48, 40, 25. How many? Multiplying as you go.

C: Will do that every night when he goes to bed, he'll do a sum in his head.

Keep your mind working. And why not? There's no good being miserable, nobody don't want you.

What do you miss now?

I miss me own car. I built me own garage, bottom of the garden. Drive off, go wherever I wanted to, Scotland, Belgium, Wales, the Isle of Wight. The biggest fish I ever caught was off the Isle of Wight, a 5 foot Tope off a hand line on a boat (pause). Oh, this is terrible! I generally do better than this. This is terrible.

C: I had to give up caring because of my bad back. I used to look after Dorothy (Will's wife).

Now she looks after me.

C: But with Will is different, I love him like my dad; my dad, my husband, my best friend. I haven't got a boyfriend, I'm not allowed to have a boyfriend. Do you love me?

Of course I do. I wouldn't be here otherwise. My son, now he has trouble with his feet, his wife is pretty ill, so there wouldn't be no home left for me. I'd have to be in a home. I don't want to go.

C: No you're not going to go!

I'll put another line on I think.

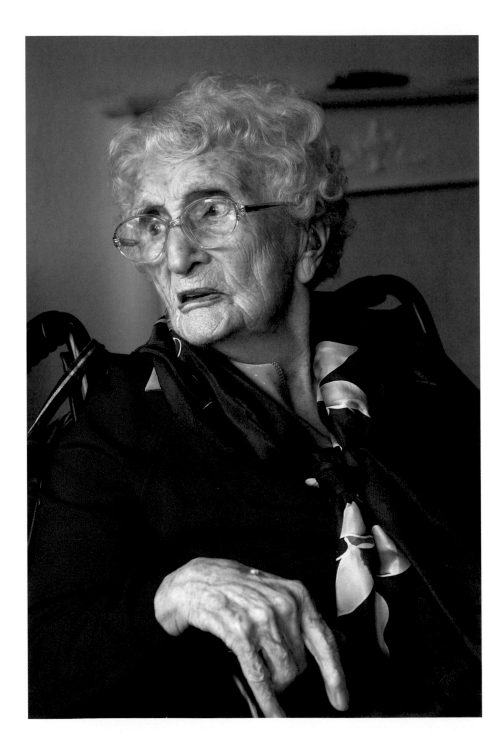

Gladys McDonald

Born 26 May 1909

Daughter, Judy (J): Mum's been here for 7 years now. When she came in she was in a terrible state but they did this to her, they kept her alive.

So you think she's improved?

J: Certainly, certainly. She was very thin, she wasn't eating.

(Carer comes in) This is a very good carer to me. They're all very good here. It's very, very clean. The thing about it is it's too clean!

Carer: You can't have it too clean!

(Laughs). (Referring to small baby who is her great-granddaughter). She's ginger isn't she? Hey! She's a ginger babe.

Have you got any more children?

I've got Jeff, I've got Thomas, Edward, oh, Alex.

J: There were five boys and one girl.

I don't understand why. They do say that little boys are more loving... I didn't have Judy till I was 37, and I thought what an age! I didn't expect another girl but she came and I've got another called Irene, and she's a bit like me. She's very... I can't explain.

Tell me. How do you see yourself?

Why, am I like Irene? She rang me up last night and said, "Please behave yourself," and I said, "I can't hear a word that you are saying" and we ended up having a row. I won't say the word she used. But, I put the phone down. What do you want to know about me?

Just how you see yourself?

Well, I'm wonderful really. I eat, and it's very good the food here, but I've gone off dinners. I live mainly on soup. This morning I had a beautiful bowl of porridge, marmalade and toast and it was lovely. And a nice cup of tea. This place is really ideal.

J: Tell him how naughty you are! She starts terrible arguments with everybody.

I am, yes. Why should old women want two cups of tea at nine o'clock at night? It isn't right, there'd be wee wee in the bed all night. So I tell them.

But do you feel quite well yourself?

Yes. I say to myself sometimes, "The old heart is going," but it's just, nothing. And a lot of my swollen legs, nothing. And when I fell out of bed they never thought I'd live, but I was all right just a few days after. Quite okay. Yeah.

J: (Showing photo) That's her when she fell out of bed. Three weeks later she didn't have a mark on her face.

Red eyes and a big nose! (Laughs) I fell between a little chest of drawers in the bed, and I couldn't get out, and the next time I fell it was the same thing…
I used to live with my husband in Grove Road but suddenly he began to lose his memory, and it just went, and that was it. So I came here, and they are very good to me. I see it as home here, I really do. And there isn't a smell is there? Because if you go into old people's homes there is that urine smell. I'm sorry to say it is the men that cause it. But here every part of this room is clean. It is.

Do you think that anything in particular has kept you going?

Yes there is. Yes, to get to my age you haven't got to drink, not these bottles of wine you have on the table for every meal. I don't believe in it. No drinking, but the biggest thing is smoking. Do not smoke! Anyway, what else you want to know?

What was your husband like?

He was a silly bugger, but he was all right. Yes. He was a good man. One day, he bought this car, and he thought he'd take it up the Whittle pass and he was a long time coming home so when he came in I said, "Wherever you been?" (Long story about returning a purse). Silly bugger, but he was a good man.

Gladys, what do you like to do now?

Well they have cake making and, well, no. I came down for breakfast and four of them at that table never open their mouths, they just sat looking at one another. And suddenly one of them starts to get up, she'd be about 90, so I said, "Where are you going you stupid old fool?" Oh, I do get a mind telling them off.

Do you have any friends here?

I don't like to mix. I made more friends with the carers because they asked me things. And I made a very good friend because he comes here and gives a concert on Thursday afternoon, and he's a nice lad, no he's not a lad he's 70, and I've got to know him very well, and he said, "I'm going to sing a song for you Gladys." I said, "Okay David." Do you know what it was? Frank Sinatra singing, "I've got you under my skin"! Now wasn't that wonderful? Hey? And the other day he went and sang an Irish song to Catherine and he went over and kissed her and I was very jealous about it. Yes I was. That's all I can tell you.
Think young. I believe, and I know I'm right, that there's no such thing as God. No such thing my lad. Do not smoke, keep young, have a sense of humour, and that's all I can tell you.

Are you still happy that you're alive?

Oh yes, as long as I can go on and irritate people I don't mind.

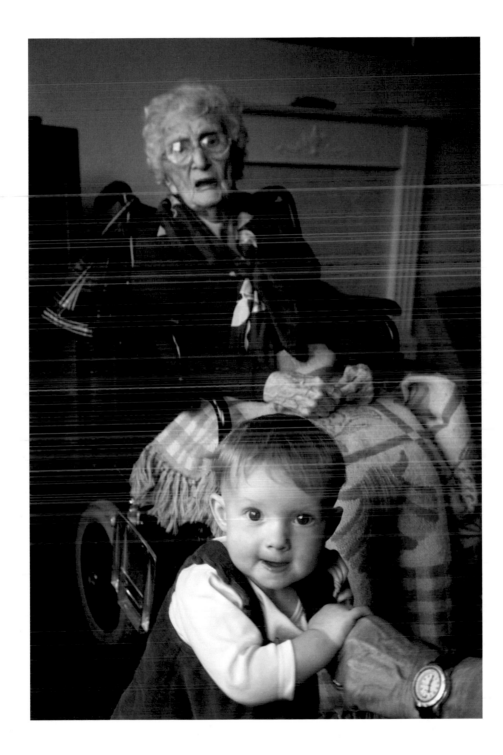

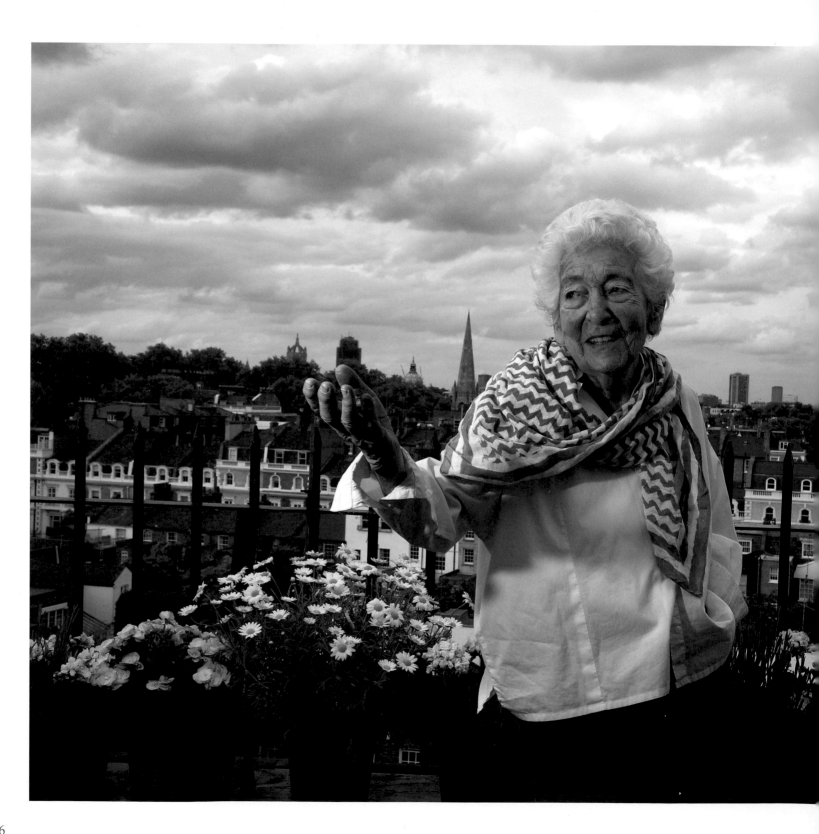

Elizabeth Juda

Born 2 May 1910

I started off being a photographer behind a Gandolfi camera. We weren't called photographers we were called operators. The operator hadn't turned up from his holiday, he loathed me anyhow, I was a darkroom boy. I was taught by Moholy Nagy (*Hungarian photographer*), who was a friend and he said, "Elspeth you've got a good eye, my first wife who taught us all is here too and I'll tell her to teach you." We were all refugees together. My God! She was hard. A hard person to please which was good. I got the job finally as a darkroom boy for a studio, so I learned it from the bottom up, which was not bad. Later I had a job photographing the medical procedures, the war wounded: airmen who had their bottoms shot off in the war, that sort of thing. They had already been sewn up in France or wherever they came from, and mine was a medical procedure, and there I was on top of the ladder and they brought the body in and the surgeon, like a sort of toreador, "My gloves, my gown!" my everything (laughs) then he said, "Is the photographer ready?" "Yes sir" and he said, "Oh, it's a bloody woman!" and I said, "I've been sent for the job, you've got to try me." But it was fine at the time, I didn't mind being called a bloody woman, I have been called a lot of things in my time.

If you had those photographs now you would have a very interesting set of photographs.

I have nothing left. Well, a bomb dropped on it, and I don't have any of my own photographs because when my husband died I had to move very quickly and I gave all the archives to the Royal College of Art who treated them very badly. Because there was a very lazy man who was a librarian and he just kicked it in the corner and the students helped themselves to whatever they wanted. Of course why not? So there's not much left and I gave that to the Victoria and Albert Museum, mostly negatives, and quite a lot of prints.

(Later, looking through the Guardian magazine publication on centenarians).

This is the same project I am photographing you for, centenarians.

Oh my God! Alice Leake, that's a great name! Tessa Grimes. Gosh. I've got a lot of colleagues.

Yes, over 10,000 of them in the UK.

(Laughs) That's a bit much. I love that, so beautiful. That's wonderful isn't it? This woman... Now, she's not happy... Poor thing, she probably only has her pension.

But generally the people I've photographed who reached that age seem to still enjoy life and that's what keeps them going, but it's certainly not everybody, some don't enjoy it any more.

Yes. Poor things... My God! She looks lovely. 108 my God!

She still plays the piano every day and says she is learning Bach.

I know exactly how she feels about Bach, it's the kind of mind that... You can't understand it, and the purity and inventiveness... I had a friend, and his mother was still alive, and she waited till the children came back and she said, "I'm waiting for you because I want to die, I want you to sit down either side of my bed and hold my hand." And she died, which was wonderful, and I'd like somebody to play Bach. That is all. That is all.

Does it mean anything to you being over 100? Is it some kind of marker?

No, a hundred, all my friends insisted on coming when I was 100 and that was remarkable. I should be wiser, I should do other things. I gave up working when I was 93. I had a studio in the Fulham Road. I made collages, and I thought – this is silly, I must give it up – and I did a lot of other things because there were a lot of other things to do. They're all done now, so I thought I must get myself another, not occupation, but something I want to achieve and now I want to do three-dimensional collages. I've got to find a place where I can make a mess. I had a studio and I gave it up because I thought – I'm too old, but now I regret it of course, now that I am old. I must find somewhere that I can walk to.

How did you meet your husband?

Well when I was seven and he was fourteen and twice my height, a huge man, I threw a snowball right in his face and he put me over his knee and said, "Little girl don't do that again, or else!" Or else (laughs) and I fell in love with him of course. I was working in Paris and he rang me from Berlin and said, "Well, shall we get married then?"
And I said, "Why not, I've waited for 12 years, since the age of seven. Yes." So that was it, and I was married for 44 years. Very good. Very difficult man. But wonderful, great, good man. I was only 63 when he died. I thought that was it, but I keep going I don't know why. I don't intend to do it at all. Why do you think that is? I'm just realising there are some things which I just can't instantly remember and it irritates the hell out of me, really it does!

You seem to be in good health.

I'm OK. I do, what's it called? Pilates, twice a week and I do it by myself. I have a board where I jump up and down and things like that, and I try to go for a walk every day, and I try to go about by myself... My greatest pleasure is going to the Wigmore Hall. I go to concerts and I can go by myself because it is very easy here, or I go with somebody, friends... There's not so many people who want to go to as many concerts as I do (laughs).

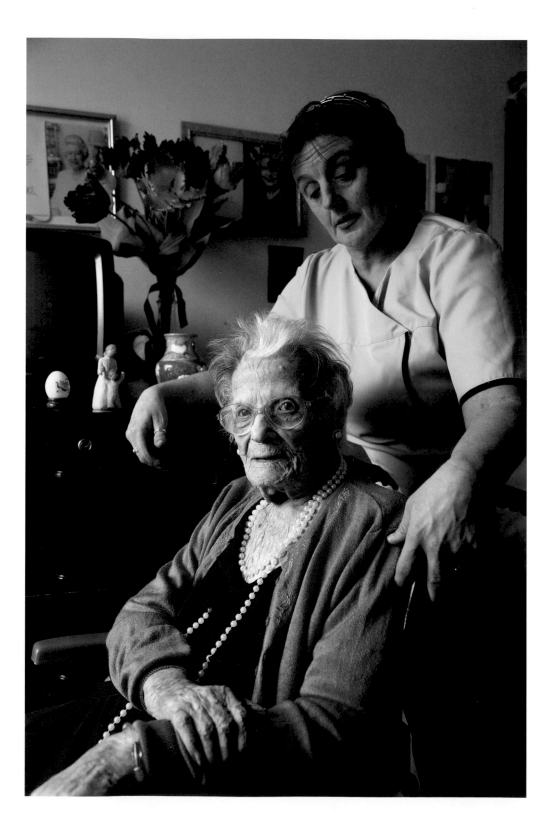

Ellen Watson

Born 1 January 1900

Care worker (CW): We will have a game of tossing later. Who cheats on that game on the table? You do! (Ellen is being photographed). She loves posing look! (Laughs and tickles Ellen) Oh, love her to pieces! Look out the window at the birds a minute. She'll soon tell you when she's had enough.

I broke his camera!

CW: You know you're the fourth oldest now in the country.

What did you do to have such a long life?

Worked, worked and worked! My mother was 100.

CW: She wasn't, she was run over by a train.

My father was about 100. I've got brothers and sisters still living! My sisters are... Audrey.

CW: That's your daughter, Audrey. You a bit confused today.

I bet she's looking everywhere for me! I haven't seen her today. I've had a good life though. I'm not grumbling, my mother was so good.

CW: She's so proud of her mum; she's always saying how loving her mother was.

I had a good life. My father was a good man, he worked on the telephones, he invented the telephone. My father invented the telephone. Did I tell you? I've been happy.

CW: Do you love us here, do you love us all?

Yeah, but I don't know about all, but I like you! I get by all right... I've got nothing to grumble about this place 'cause I think they're very good.

You are going to be 112 next January.

I didn't know I was that old. I know I'm over 100.

CW: Do you feel 111?

No! I've had some good times... I've got two, three, four brothers, still alive? Audrey, she works here, Audrey Hobbs, that's my sister. Louis. A nurse. She had three little girls in London. When she comes down I've got to be there.

CW: She likes to sing, and she likes to be in company. You were singing yesterday.

I like to dance too. I like dancing.

Are you religious?

I am religious, I like the church. I'm a Christian.

CW: What's waiting for us up there? (Points up).

Well I don't know. I haven't been up there yet! (Laughs).

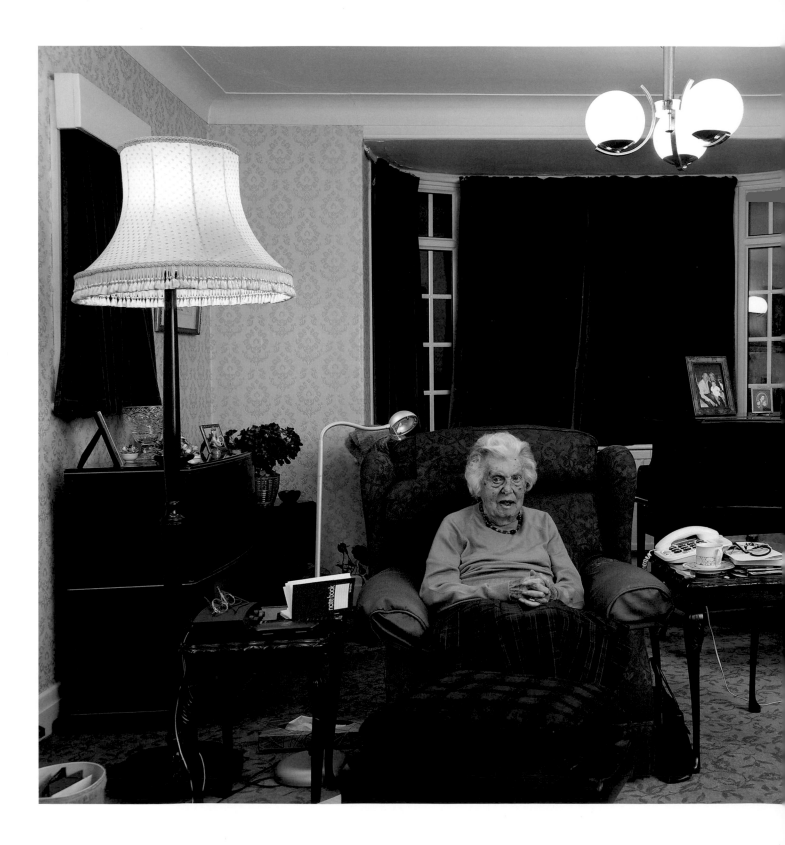

Doris Manning

Born 21 November 1907

You used to be an artist?

Yes. These are all my pictures. They've all been in Paris, the salons. And in America. I had a book of where everything was, in the lounge, in the dining room. But I can't find it now. I sold my first paintings to a solicitor. That was years ago. I had two exhibitions with Stockton Museum but unfortunately the man who wrote my exhibitions up, he came up from London from the Telegraph, but he was run over unfortunately, on a fog-lit crossing, and killed, so we lost a good friend there.

Do you still do any painting?

No. I stopped after my husband died because he was ill, and I had to watch him, so I couldn't paint at the same time. I found it was a bit difficult because you'd leave him in his study he had upstairs, and you wonder what had happened to him and you went to find him and he'd be sitting, just gazing. It was the beginning of his illness. He had Alzheimer's, but he didn't recognise that he had it.

So do you have any hobbies now?

Well, I like to play bridge, and I belong to the Masonic club. I go there on Monday, and I like walking. I like to walk down to the Post, I go round this little side alley way and round the back. Quite a nice little walk to go around the block and back again…that's another thing I used to do, tapestry and Italian needlework… I have difficulty, losing my hearing, to hear what my daughter says. I have to do a lot of lip reading. I went for lessons for a long time.

What are the advantages of old age?

Well I think if you get old without being ill or having infirmities, that's marvelous. But if you can't live a normal life that's difficult. Very difficult.

What do you miss most?

Going for long walks in the hills. Going out abroad to Austria and climbing up, no, walking up hills. My husband always, if he saw a mountain, had to get to the top of it. He pushed me up in front (laughs)… If there was more family life I think it would be better. I am very happy with my family life and it's nice to see the grandchildren, great-grandchildren, I'm lucky there.

Are you religious?

Just normal. I like to go to my little church at Elton because I know the people and they know me and I think that's good. I think religion makes a big difference to a person. The vicar comes and sees me and we don't talk religion, but it's comforting when you get old.

Fauja Singh

Born 1 April 1911

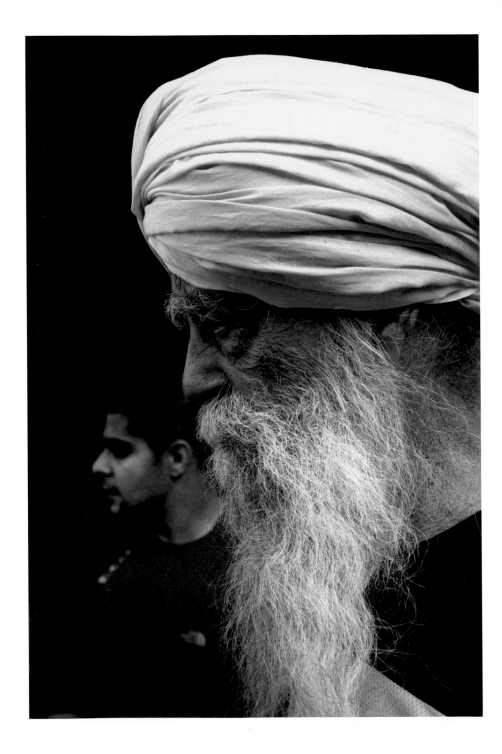

Why did you start running rather than say swimming or walking?

In India where I was born and grew up, swimming for leisure is unheard of. Even in Britain is a luxury due to the silly money asked for by pools. Running is free and I also walked too.

What ambitions do you have for running?

To become the oldest marathon runner.

Have other members of your family had very long lives?

Several of my ancestors lived beyond 100 years old.

When were you happiest in your life?

I am happy every single day. It is what keeps me alive.

Do you enjoy life now as much as you did when you were 70 or 80?

Yes. Although when I was 70 and 80 I did suffer some major losses in my life: my son and my wife.

What other interests or hobbies do you have other than running?

Sightseeing. Socialising and doing good deeds, as God wants all of us to do.

What motivates you?

Meeting new people in new places as running tends to let you get out a bit more.

What is your daily training schedule?

It is still to cover about 8 to 10 miles a day but there is more walking and jogging than in the past.

What would you say to people who want to live until they are 100?

That is up to God. It is not important to just live longer if you're going to do bad things in life. I try to thank God for the good health he has given me, and I try to help others while I am alive.

What do you eat and drink?

I eat enough to live on, no more. It is better to eat in moderation. In parts of the world people die of starvation, in other parts people die from overeating. I try to stay in the middle.

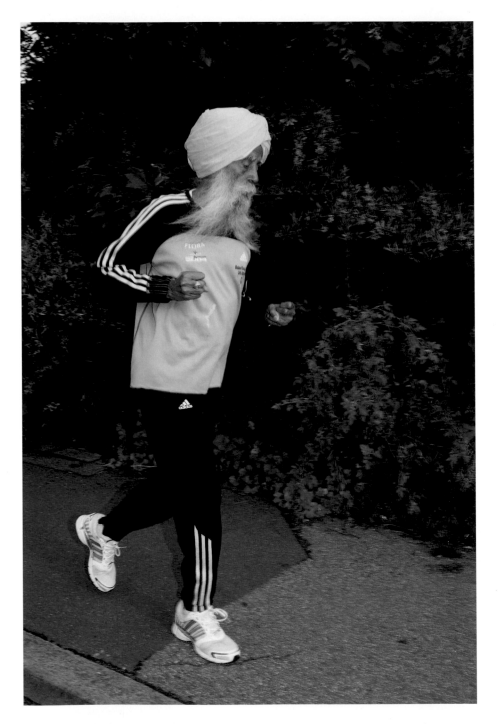

In Toronto 2011 Fauja Singh became the first, and only, centenarian to run a full marathon.